tenHaeff

Ten Haeff's paintings are an extraordinary kind of inward thinking.
I stress the thinking, though of course
these thoughts begin in vision and feeling.
 —HAROLD ROSENBERG

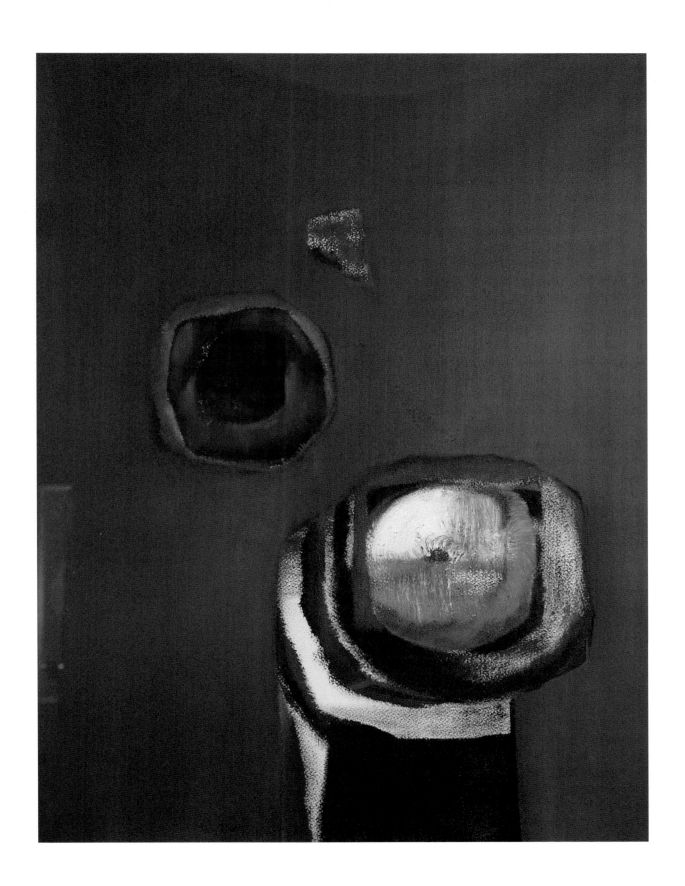

Signal, 1964
Oil on paper, 30 x 22 inches

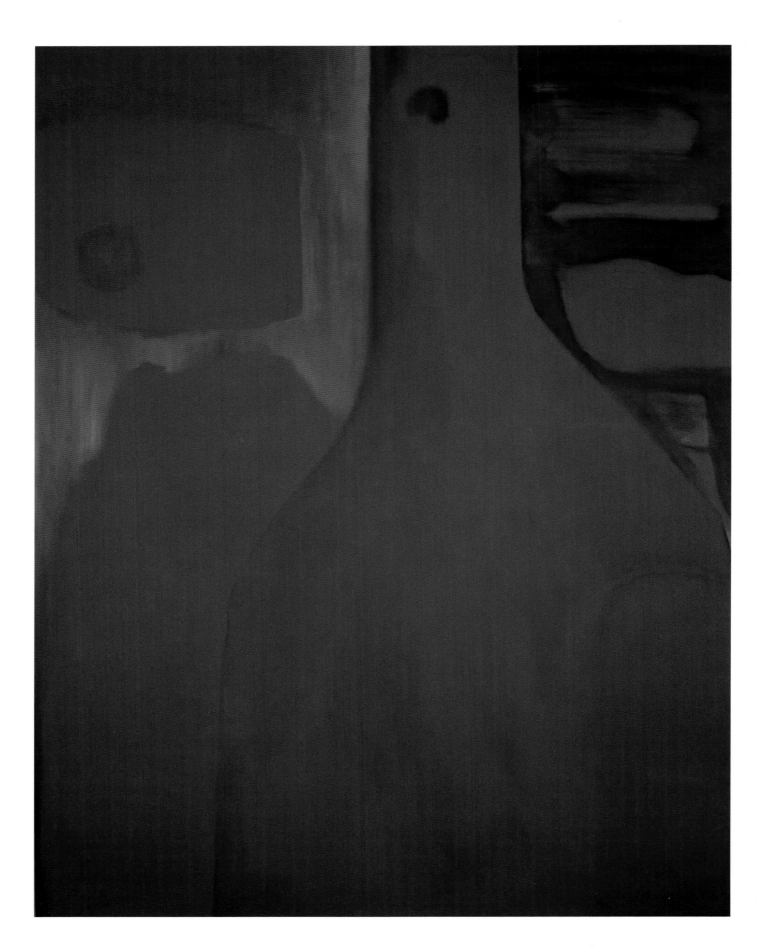

tenHaeff

JOHN GITHENS

NABI PRESS

NEW YORK

COVER: Photograph by Hans Namuth, 1960
© 1991 Hans Namuth Estate Collection,
Center for Creative Photography, University of Arizona

ENDPAPERS: *Chiromancy Series: Max Lerner*, 1981
Ink and colored pencil on paper, 22 x 30 inches

OPPOSITE TITLE PAGE: *Gleiche Gegenüberstellung,* 1963
Oil on canvas, 74 x 58 ½ inches

First published in the United States of America by

NABI PRESS
137 West 25th Street
New York, NY 10001

© 2004 Nabi Press/John Githens

ISBN: 0-9747030-0-1

CREDITS:
Book design: John Esten
Digital composition: Mary McBride
Printed in China

contents

Chiromancy Series: Alfonso Ossorio, 1979
Ink on paper, 24 x 16 inches

8

acknowledgments

Without the astute advice and enthusiastic encouragement of John Esten, this book would not have come into being and without his perceptive eye and enormous professional experience as a designer could not have achieved its present form. Others, too, have contributed much to this project. Regina Kremer Cherry has photographed a large number of the artist's paintings and drawings—sometimes under difficult circumstances in the crowded studio of the artist, but always with great conscientiousness to her craft. Adelaide de Menil graciously granted permission to reproduce photographs that are works of art in themselves, rather than simple documentation of the artist's work, that is, her imaginative dioramas of ten Haeff's hanger series in natural settings. The estate of Hans Namuth, and his heirs, Peter Namuth and Tessa Namuth Papademetriou through the Center for Creative Photography have accorded their permission to reproduce the photo of the artist in her Amagansett studio which appears in this book. Other portraits of the artist are by Linda Alpern, Inge Morath, and Susan Wood. Several collectors have facilitated the reproduction of works by the artist which are now in their collections: Carlos Brillembourg, Clara Brillembourg, Maïka de Riocour de l'Espée, Mary E. Kaplan, Min-Myn and Val Schaffner, Joan K. Davidson, Ted Dragon, and Elizabeth Strong-Cuevas, among others. Elizabeth Parella provided invaluable help in proofreading and correction. Mary McBride assumed the task of preparing the work for the printer. □

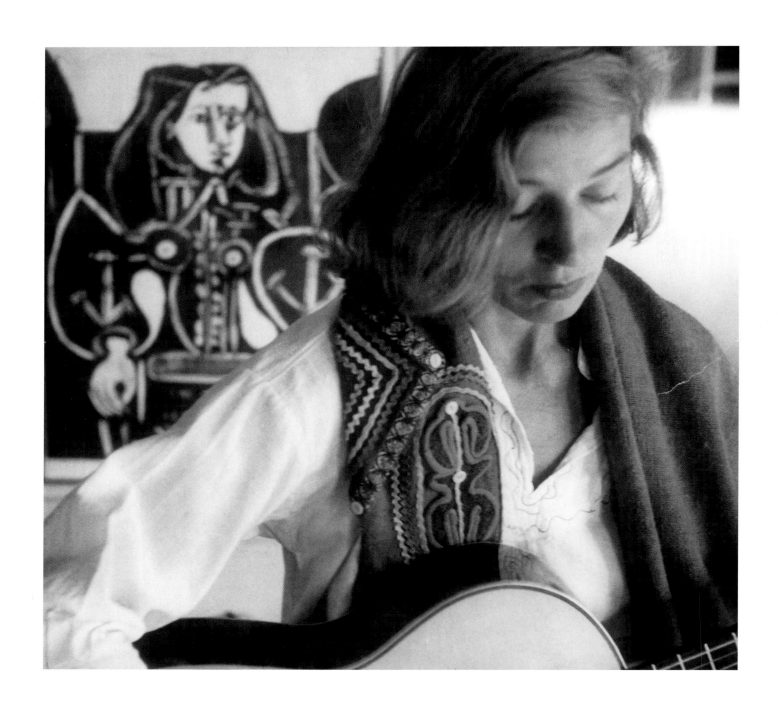

Photograph by Susan Wood, 1963

ten Haeff

trines and transits

Ingeborg ten Haeff was born in Dusseldorf, Germany on July 31, 1915, the second of two children born to Emmy Lindenberg and Hugo ten Haeff. Emmy was from Dusseldorf, daughter of the owner of a large confectionary business on Flingerstrasse in the old city. Three years earlier, in 1912, she had married Hugo ten Haeff of Wesel, an old Hanseatic city at the confluence of the Rhine and Lippe rivers at the border of the Netherlands.

The history of Wesel is intertwined with the history of the Netherlands, and so is the surname ten Haeff. Early ten Haeffs were in corn exchange and traded in iron nails. A more recent, but still distant, kinsman was one of the founders of the Dutch East India Company in 1601. Ingeborg's paternal grandfather was engaged in the rapidly growing illuminating gas industry, and his son continued to enlarge the family business.

Hugo ten Haeff, or Ten, as he was known to intimates, brought his bride home to an impressive villa he had built for her at 11 Rohleerstrasse, a street named after one of the heroes of Wesel who had lifted the Spanish siege of the city in the 17th century.

In 1914 the Great War began and ten Haeff served as an officer in the Kaiser's army. He and his business survived the war unscathed, but the end of the war brought privation and turmoil to the Rhineland. In the main, these hardships were not apparent to children of a privileged home, with servants and well-stocked larders. The so-called "Red Army" of striking workers from the Ruhr shelled Wesel in 1920, but the regular army intervened and order was restored. As a gesture of social reconciliation, Emmy ten Haeff sent her daughters to the *Grundschule*, or regular public school, instead of private school as would have been customary to their station. She made a point of inviting children of imprisoned Spartacist revolutionaries to share breakfast with her own children before they went off to school.

Soon misfortune of a personal nature struck this otherwise tranquil household spared by the war and its aftermath. At class in school, Ingeborg remembers a classmate telling her teacher that Herr ten Haeff had just been killed in an accident. The full meaning of this did not become clear to Ingeborg until her parents' servants arrived at school to take her and her elder sister Helene home. Their father had indeed been killed in an automobile accident early that morning on his way with four friends and a chauffeur to a bird shoot. Ingeborg was just five at the time and her sister, Helene or Leni, was seven. Emmy, the new widow, was only twenty-eight.

It was a wrenching adaptation for all three. Emmy took over her late husband's business. Acknowledging her inexperience, Emmy decided to concentrate on distribution rather than production. This grieving newly-fledged businesswoman had many obstacles to surmount, of which gender was but one.

Under the burden of financial reparations imposed upon Germany at Versailles, the value of the mark declined precipitously and an unprecedented hyperinflation took hold. Bank notes and coin disappeared from circulation and German cities, including Wesel, issued *Notgelt* or emergency tokens and scrip, to replace normal cur-

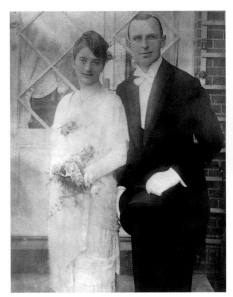

Photographs: Emmy Lindenberg ten Haeff and Hugo ten Haeff, May 14, 1912.

Ten Haeff residence, Rohleerstrasse 11, Wesel am Rhein.

rency. Business conditions were difficult, but Emmy and her firm managed to survive and even prosper in this unpromising environment. In those days it was the custom to sit for group photographs at meetings of trade and professional organizations, and in portraits of the illuminating gas association Emmy ten Haeff is invariably the only woman to be seen.

Ingeborg and Helene continued to live in the villa on the Rohleerstrasse under the care of a series of governesses as Emmy traveled about on business. In the winter there would be family holidays in St. Moritz or Arlberg; in the summer there would be holidays at the beaches of Scheveningen. Still a handsome woman in her late thirties, Emmy met and married Hubert Hempel, owner of a civil engineering and construction firm based in Berlin. This would be a second marriage for both. Emmy moved her business to Berlin, and she and her two daughters, ages 13 and 15, moved into the imposing mansion of the new husband and stepfather at Eberaschenallee 13-18 in the West End district.

Ingeborg and her sister Helene were enrolled at the West End Schule, a progressive school for girls. There Ingeborg would establish lifelong friendships with Esther Mendelsohn, daughter of the seminal modernist architect Erich Mendelsohn, and with Alice Wyss, daughter of a distinguished diplomat and scholar who had served as German minister to China and later as Ambassador to Paraguay. Although both these friends were to emigrate in the mid-1930s, all three would later be reunited in the United States.

As owner of a large firm engaged in public works projects, Ingeborg's stepfather began to find it necessary to cultivate relations with members of the rising National Socialist Party to the dismay of Ingeborg's mother. When she would protest his invitation of party officials to their home, Hempel countered that he had his business to consider and hundreds of employees whose wages depended upon government contracts. A rift developed which eventually led to their divorce in 1936. Emmy and her daughters moved to an apartment on the Kurfürstendamm and Emmy now devoted her full attention to the business she con-

tinued to operate while married to Hempel.

After the West End Schule, Ingeborg began to find her own way in the world. She was tall, blonde and athletic, with a bearing that was as imposing as it was attractive. She was outgoing and attracted to the arts, and to people in the arts. As a child she had had a gift for mimicry and a fine voice, so it was natural that she would gravitate and be guided toward the study of acting and vocal performance. She attended the classes of Maria Schulz-Dornberg, a prominent singer at the Staatsoper. At the same time she studied acting with the well-known actor Walter Frank who had created the role of Garga in Brecht's *In the Jungle of the Cities*. Students staged performances at these schools and Ingeborg often found herself designing and painting stage decorations for such events, usually enjoying this work more than the preparation of the acting or singing part she might be assigned in these plays or operas. While Ingeborg had a striking stage presence, a good voice, natural musicality, and strong emotional projection, she suffered occasional bouts of stage fright and difficulties with her lines. All the same, Schulz-Dornburg and Frank encouraged her to continue, and so she did.

Ingeborg enjoyed an active social life with many friends, some contemporaries like Ise Vermehren who was already a star at the *Cabaret der Komiker*, but often older mentors like Edmund Stinnes, Alex Röchling, Graf von Plessen, Graf Mariano von Sierstorff, and Gero von Gaevernitz who was later to work closely with Allen Dulles in intelligence operations against the Third Reich.

The most important mentor, perhaps, was a man whom Ingeborg never really came to know, a world-weary stranger who talked to her about Lao Tze and who mysteriously gave her a vivid German translation of the "Way of the Tao," a text which Ingeborg believes has helped her understand all that she had and would experience.

On a spring day in 1939, Ingeborg was invited to lunch by Hugo von Habermann, an artist who had painted her portrait, together with a large company of friends at a restaurant on the shore of the Wannsee. Soon an acquaintance, Alvarengo, the young first secretary at the Brazilian Embassy in Berlin was to appear with another young man in tow. The first secretary was no stranger to most

of this fashionable set lunching on the terrace, and Alvarengo asked if he and his friend might join their party. The friend was introduced as Dr. Lutero Vargas, eldest son of the President of Brazil, Dr. Getulio Dornelles Vargas. Places were found for the new arrivals, and Lutero took a seat next to Ingeborg.

Lutero Vargas had completed his medical studies in Brazil and in France, and was now studying surgery in Berlin under the guidance of one of the world's leading thoracic surgeons, Dr. Ferdinand Sauerbruck. Apart from medical terminology, Lutero had little German but could command a winning smile and a few basic words. Somehow he and Ingeborg managed to converse and arrange a subsequent meeting. Soon they were in love, each enchanted with the exoticism of the other. Ingeborg had other suitors and proposals of marriage but Lutero interested her more than the rest.

In September of that year, as their love continued to deepen, Germany and the Soviet Union invaded and partitioned Poland, and England and France declared war on Germany. For nine long months the so-called Phony War dragged on with neither side wagering to engage in open combat. Suddenly in May of 1940 Lutero informed Ingeborg that he would be leaving Berlin immediately. Benito Mussolini had secretly informed the Brazilian government that a new, active phase of the war was about to begin. Eager to sway Brazil to the side of the Axis, or at least to secure Brazil's neutrality in the upcoming conflict, Mussolini offered to have the son of the Brazilian president flown back to Rio in a plane piloted by his own son. At the urging of the Brazilian Embassy in Berlin, Lutero accepted this proposal. He would return to Brazil via Rome, Lisbon, and the Azores.

Under the circumstances, it was hard to envisage a future for Lutero and Ingeborg's relationship. They parted sadly, but a scant few weeks later a telegram from Rio arrived at the ten Haeff apartment: "I want to marry you—Our Embassy will arrange everything." Plans for Ingeborg's departure were to be secret, and Ingeborg disclosed them only to her mother and to one close friend, Baroness Gisele von Fittinghof.

A passport and exit visa were issued, but only after an inquiry into the reasons why Ingeborg would choose to marry a foreigner and a lecture about the superiority of German husbands. Soon Ingeborg, in the company of a Brazilian diplomat, was on board a plane bound for Rome and then a flight on to Portugal. In Lisbon arrangements had been made for Ingeborg to board a Portuguese vessel, the S.S. Baje, bound for Rio de Janeiro, again in the company of a returning Brazilian consular couple.

Lisbon was thronged with refugees from France and from the Netherlands, all clamoring for visas to the safety of the New World. Only a privileged few could hope to board the rare departing steamer such as the S.S. Baje. Ingeborg had no Portuguese and little English or French. Because of articles that had appeared in the Lisbon papers about her engagement to the son of the President of Brazil, Ingeborg became the object of some attention on the part of émigrés eager to be admitted into that country. Although Ingeborg was in large measure shielded by her Brazilian companions, people attempted to court her favor by offering her presents and jewelry. But, there was simply no way she could intervene on their behalf before a president she had not yet met and whose language she did not yet speak.

Portugal was a neutral country, and in principle ships under its flag were safe from attack. Ingeborg's passage was uneventful, but the S.S.

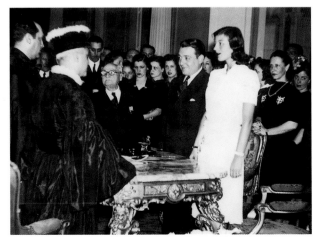

Civil marriage ceremony of Dr. Lutero Vargas and Ingeborg ten Haeff, Rio De Janeiro, 1940. The elderly man wearing glasses is General Vargas, father of the president of Brazil, Dr. Getulino Vargas, and grandfather of Dr. Lutero Vargas. General Vargas was the hero of the Paraguayan War.

Palacio Guanabara, Rio de Janerio

President Getulio Vargas, Ingeborg ten Haeff, and
Dona Darci Sarmanho Vargas, 1940.

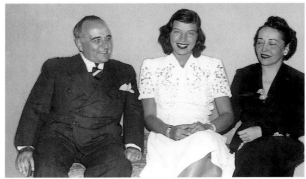

Baje was sunk on a return crossing later that year.

As a condition of her exit visa, the German Foreign Ministry proposed that Ingeborg be received by the German Ambassador to Brazil upon her arrival and that she be given the hospitality of the German Embassy until her wedding took place. It was arranged that a party from the Embassy would be waiting at the pier to meet Ingeborg when she disembarked in Rio. Within sight of the city, the ship came to a halt at the entrance to the harbor. Anxious passengers gathered on deck to learn why the ship had stopped. Soon a launch approached and Ingeborg was informed that she and her luggage would be transferred to this smaller vessel. Her Brazilian companions made a sign of the cross over her as she climbed down a rope ladder to the launch. There, waiting for her on the deck was Lutero Vargas, dressed in the very suit she had last seen him wearing in Berlin when they had parted.

The launch raced to a waiting car in Niteroy, and from there Ingeborg and Lutero were driven to the Palacio Inga where Ingeborg was introduced to Dona Darci her future mother-in-law, and to Alzira Amaral Peixoto, Lutero's sister, wife of the governor of the state of Rio de Janeiro and right hand of President Vargas. Until the wedding Ingeborg was the houseguest of the Corea family who were related to the Vargases by marriage. Three days later the wedding took place: the civil ceremony in the Palacio Guanabara, with the entire presidential family in attendance, was followed by a religious ceremony at the church of Santa Teresinha.

After a honeymoon on the estate of the Sampaios near Petropolis, the newlyweds moved to a house in Urca. Every day they would dine with President Vargas and his adjutants and immediate family at the Guanabara Palace. Soon Ingeborg was pregnant and gave birth to a daughter, Candida Darci Vargas, in July of 1941. Lutero was active in orthopedic practice, and Ingeborg, in the free time available to her, was drawn toward the cultural scene in Rio de Janeiro. President Vargas offered Ingeborg his box at the Teatro Municipal, and Ingeborg regularly attended concerts and rehearsals there with her new friend Nini Corea.

Musical and cultural life in Rio was greatly enriched by recent refugees from Europe, and Ingeborg became acquainted with the émigré German conductor Erich Kleiber. Drawing on her vocal training in Germany, Ingeborg turned her attention to Brazilian folk song and began to study guitar with Patricio Teixero, an Afro-Brazilian guitarist and radio personality of the day. Ingeborg also made the acquaintance of Count August Zamoyski, a Polish sculptor who had fled to Brazil. Zamoyski made a sculptural portrait of Ingeborg, and she studied the rudiments of sculpture under his guidance. Ingeborg became acquainted with Candido Portinari, the most admired Brazilian painter of the 20th century. Portinari offered to paint Ingeborg's daughter, Candida, and made Ingeborg a present of this portrait.

In 1942 Ingeborg and Lutero were introduced to Nelson Rockefeller who was visiting Brazil as Coordinator of Inter-American Affairs for the U. S. Department of State. Rockefeller invited the young couple to make a tour of orthopedic hospitals of the United States, and in a more general way to promote good will and understanding between Brazil and the United States. This took the form of a ten-month rail tour of the United States. Lutero and Ingeborg were flown to New York. The bulk of their luggage was to come by sea but was lost when the vessel carrying it came under attack by a German submarine and sank. Ingeborg and Lutero had limited wardrobes, but they were received by many of the notables of the day—Fiorello LaGuardia, J. Edgar Hoover, Henry Ford, Walt

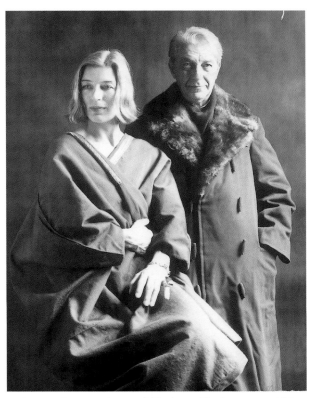

Ten Haeff with Paul Lester Wiener
photographed by Evelyn Hofer.

Disney and Preston Sturges, to name but a few.

By the time they had returned home to Rio, the Brazilian government had decided to contribute a small expeditionary force to the Allied Italian campaign. Lutero joined this unit and departed again for the U.S. and later Rome, while Ingeborg accepted the invitation of Mrs. James Forrestal, wife of the U. S. Secretary of the Navy (later, Secretary of Defense) and of Maria Martins, wife of the Brazilian Ambassador to Washington, and noted artist in her own right, to revisit the U.S. with her daughter Candida. Nelson Rockefeller arranged for a scholarship for Ingeborg at the Juilliard School of Music.

At the end of the war, Lutero and Ingeborg were again reunited in Rio, but to Ingeborg's great surprise Lutero suddenly demanded a divorce. After seven months of uncertainty, Ingeborg resolved to make a new life for herself in New York. She already had a circle of acquaintances there, and friends offered her a place to stay until she could establish herself. Paulo Sampaio, the husband of her close Brazilian friend, Gilda Sampaio, was director of a new Brazilian airline, *Panair do Brasil*, and he arranged for Ingeborg to fly to New York on a Lockheed Constellation that was returning to the U.S. for servicing. With her Brazilian diplomatic passport, Ingeborg could not seek regular employment, but the well-known art dealer J. B. Neumann, who represented Paul Klee and many of the artists whom the Nazis had labeled degenerate, offered her a position at his gallery on 57th Street. Before long Ingeborg met the man who would become her second husband Paul Lester Wiener, an architect and city planner who had designed the United States Pavilion at the 1937 Paris World's Fair, and who had participated in the design of the Brazilian Pavilion at the 1939-40 New York World's Fair. During the war Wiener had designed a new factory town in Brazil for the construction of aircraft engines, Ciudade dos Motores. By this time Wiener had founded a firm called Town Planning Associates in partnership with the émigré Catalan architect Josep Lluis Sert, and had begun a series of major city planning projects in Latin America. To marry Ingeborg, Wiener divorced his second wife, Alma Morgenthau Wertheim, the sister of Treasury Secretary Henry J. Morgenthau, and moth-

er by a prior marriage of Barbara Tuchman and Nan Simon.

In 1948 Ingeborg and Paul Lester Wiener set out for Colombia, where, in partnership with Le Corbusier, his firm would draw up a new master plan for the capital city of Bogotá, ravaged by recent civil unrest. Other projects followed in Colombia as well as in Peru, Venezuela and Cuba. During long stays in Bogotá, Lima and Havana, Ingeborg would begin to collect pre-Columbian and Colonial art and artifacts. In the beginning of the Fifties, Ingeborg and Paul decided to spend their summers in East Hampton, at first in rented houses in the Georgica section. Then in 1953 sculptor Jacques Lipchitz informed them of a barn that Jeffrey and Penelope Potter were preparing to rent out on their Stony Hill Farm property in Amagansett. Ingeborg proceeded to make that her summer home for the next 43 years. Photos and an article about Paul Lester Wiener's simple but innovative renovation of this barn were published the following year in the French architectural journal *Architecture d'Aujourd'hui*. Two years later, in 1955, Ingeborg and Paul moved from a studio on 55th Street in Manhattan to the apartment on Washington Square which Ingeborg continues to occupy to this day.

In the late Fifties, Ingeborg came to the realization that she that what she wanted to do most was to paint. She enrolled in the drawing classes of Elsa Tenhardt at New York University. Although Tenhardt normally required her students to complete drawing classes before entering painting class, Tenhardt soon waived this requirement for Ingeborg and admitted her

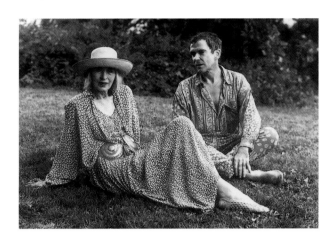

directly into painting class. After a few months, Tenhardt advised Ingeborg to skip class altogether and to work on her own. In recognition of what she perceived to be Ingeborg's originality, Tenhardt proposed regular visits to Ingeborg's studio in the capacity of mentor and critic rather than of teacher. Soon Ingeborg had her first solo exhibition at the gallery of the New School Associates. Shortly after that, in 1964, Godula Buchholz, daughter of the famous gallerist Karl Buchholz and herself owner of a major gallery in Munich, chose three canvases of Ingeborg's for an important traveling exhibition in Germany, *SüdAmerikanische Malerei der Gegenwart*, along with canvases by Obregón, Szyszlo, and Botero.

In 1967 during a summer visit to Europe, Ingeborg's second husband, Paul Lester Wiener suddenly died in Munich of a heart attack. Wiener's associates, architect and planner Richard Bender and interior designer Ala Damaz, completed the work that was already underway at Wiener's office and Ingeborg closed the firm.

As a gesture of support to Ingeborg in this difficult moment, Jacob M. Kaplan of the J.M. Kaplan Fund offered her a challenging commission. The existing museum at the New School University, under the direction of Paul Mocszany was closing, and Kaplan, as one of the major benefactors of that institution, proposed that Ingeborg make a survey of her large circle of artistic and intellectual friends with a view to determining the prospects and possibilities of a new museum at the New School. With the vital assistance of Professor Carl John Black of Bard College, Ingeborg interviewed Marcel Duchamp, Dorothy Norman, Josep Lluis Sert, Harold Rosenberg, Dwight Macdonald and numerous others, compiling their views, visions and suggestions into a report that was delivered to J. M. Kaplan Fund and to the Trustees of the New School University.

Alice Mannheim Kaplan, wife of J. M. Kaplan and president of the American Federation of Arts, invited Ingeborg to an art tour of the Mediterranean and North Africa, and later to an art tour of South America.

Through Professor Black Ingeborg met the man who would become her third husband, John Lawrence Githens, a translator and scholar of Slavic languages who was teaching Russian at Vassar College.

In 1969 Ingeborg was offered a large retrospective exhibition at the Hudson River Museum in Yonkers, New York, in conjunction with her old friend Bauhaus artist and designer Herbert Bayer. The exhibition was entitled *Two Visions of Space* and included 46 paintings by ten Haeff as well as 69 paintings by Bayer. In the same year Ingeborg had her first exhibition at Emmanuel and Elaine Benson's new gallery in Bridgehampton, New York. In the ensuing years Ingeborg would show many times at the Benson Gallery, later at Arlene Bujèse's Benton Gallery in Southampton, and in recent years at Val and Min-Myn Schaffner's Nabi Gallery in Sag Harbor, New York. In 1973 there was a juried award show of eight of her paintings at the Parrish Art Museum in Southampton, and in 1974, a retrospective show curated by Eloise Spaeth at the Guild Hall Museum in East Hampton entitled *Then and Now* in which Ingeborg participated along with Jimmy Ernst, John Ferren, Paul Brach, Miriam Schapiro and Alfonso Ossorio. In 1976 Ingeborg had a solo exhibition of paintings and drawings at Galerias Mer-Kup in Polanco, Mexico City.

Ever an enthusiastic traveler, Ingeborg and her third husband have journeyed extensively over the last three decades in Asia, Central and South America and Europe. □

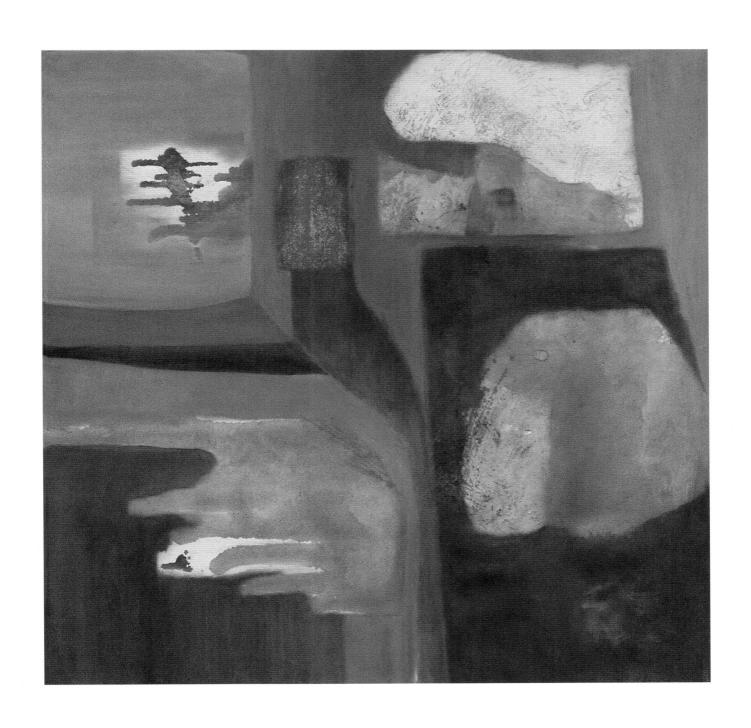

Man's Voyage No. 1, 1965
Oil on canvas, 40 x 40 inches

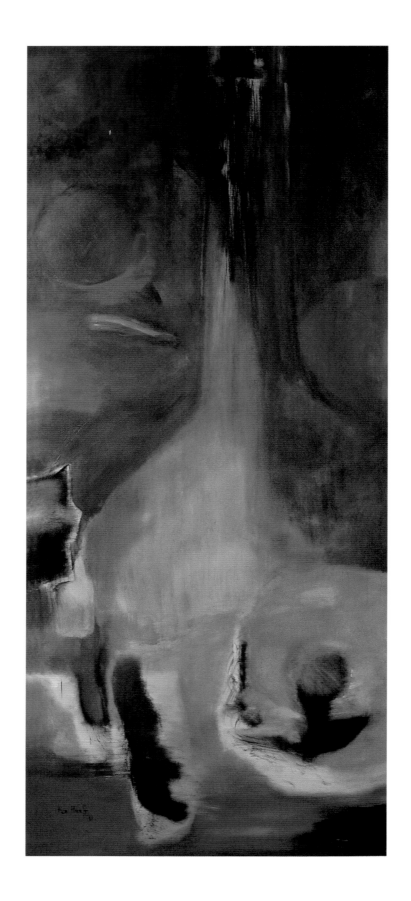

Das Unaufhaltsame, 1961
Oil on Canvas, 83 x 36 inches
Collection Maïka de Riocour de l'Espée

ten Haeff's art:

spiritually driven probings

Throughout a long career as an artist concerned primarily with the expressive potentials of painting, Ingeborg ten Haeff has always brought an acute intuitive force to her art and has tended to infuse both abstract and recognizable subjects with talismanic properties.

Her stylistic approaches have varied and evolved, yet certain general qualities recur, including an interest in creating forms (such as massive, bottle-like silhouettes) that serve as metaphors for human beings. There is also an interest in treating each new stylistic approach as a way of revealing special insights, and a tendency to explore the possibilities of a visual container. Over the years, these ideas about containment emerge in the bottle-like symbols, in geometric units holding colored pigment, in ovoid contours forming symbolic heads, and in outlined human hands that become storage places for both the subject's personal history and the artist's own impressions.

As with all artists, ten Haeff's work and contributions should be considered in the context of the intellectual and creative environment of the time. The postwar art world atmosphere surrounding ten Haeff in New York was initially filled with talk about finding the edge between invented abstractions and visual associations with life. Later the emphasis was more on testing the methods of art itself — scale, pigment, color, brush stroke or process — as primary content for visual experiences.

Unlike her art world contemporaries who were raised in the United States, ten Haeff brought to her endeavors a sophisticated and deeply felt awareness of philosophy. Most who were European-educated also came to this country with a sense of angst and a consciousness of the scholars in all cultures who addressed the human condition. Ten Haeff was particularly drawn to concepts of flow and harmony in the writings of Lao-Tze. It is possible to speculate that her knowledge of a broad range of theoretical issues contributes to a tendency to create paintings and drawings that could be equivalents to metaphysical insights.

Large canvases from 1961, such as *Dark Sun* and *Das Unaufhaltsame*, are among the first manifestations of ten Haeff's philosophical attitudes. Both use the natural transparency of a glass bottle as a device for connecting the eye to a painterly, ephemeral background that gives the impression of a cosmic, mysterious realm. The recognizable object becomes a medium through which one reaches something perceived as extrasensory. In later phases of her career, ten Haeff would again employ the idea of connection with her treatment of complex, multifaceted heads and in the way she gave supernatural, expressive powers to hand motifs.

These 1961 works, compelling in their scale and impact, allow segments of bottle contours to act as primary visual forces. In this regard they are in tune with the reductiveness that was being explored by a number of avant-garde artists. Distilling imagery from observed forms became an important goal.

The general trend towards a more intense focus led to a broadening of the investigation of sensory responses. Pigment, for example, turned into a primary expressive tool. Ten Haeff treats the movement of color and the melting and dissolving of paint as part of her subject in these early Sixties examples. Light spreading through briskly brushed, cascading paint in "The Wounded Bride" creates an effect that is simultaneously descriptive, cosmic and abstract. A number of paintings from this period were included in the artist's well-received exhibition at the New School in 1966.

Swift, broad passages of color, often applied in energetic strokes, lend considerable vigor to the early Sixties canvases and link them to the prevailing Abstract Expressionist sensibility. This association is evident, too, in the way strong, emotionally charged tones define the composition and provide a feeling of continuous motion.

But ten Haeff's conception of color's role has always been even more complex. A 1963 series of monochromatic interpretations of her bottle motifs, in red, blue and yellow, serves as a force-

ful comment on her ideas about balance, equilibrium and position, even though the series can also easily be placed within the context of the investigations of perceptual vibrations and optical shifts that were being explored by her contemporaries. The large *Gleiche Gegenüberstellung*, with its dominant red bottle shape pushing beyond its essentially abstract surface, activates optical ambiguities and tensions and also allows the central shape to sustain an iconic presence. In testing other aspects of color theory in subsequent years, ten Haeff continued to weave in principles of perception when she explored a more muted palette and even allowed black to define plane, a role she once reserved for vibrant, resonant hues.

Ten Haeff's grasp of otherworldly content, including fantasy, has consistently set her somewhat apart from colleagues who have concentrated solely on abstraction's many possibilities. There has always been a sense of independence in her approach, perhaps in part because of her background in Europe and in South America and perhaps, too, because her training was outside of the art academy system. She had absorbed Gauguin's arbitrary treatment of the picture plane and his freedom to synthesize form, and had also admired Matisse's ability to structure a painting using only color. It would seem that she was also affected by Surrealism, the next major step that energized portions of the intellectual community during her formative years. The way the Surrealist movement encouraged the mind to reach and discover what is normally unseen would have been important to an artist interested in subjective ideas.

Beginning in 1964, ten Haeff's art begins to make use of an eye motif—a concept much discussed among the Surrealists because it so effectively symbolizes a path for processing newly-found imagery. Ten Haeff used the theme in a number of ways and in various media. Perhaps its appearance is most profound in *Signal*, where the shape is a double-reference viewing device functioning both as an eye and a mechanical opening to a vast, distant ocean horizon. The message generated by this signal shape makes the adjacent amoeba-like red and black form also read clearly as an eye.

Another significant use of the eye occurs in several of ten Haeff's complex and powerful pencil drawings from the mid-Sixties. Here the motif seems buried in an allover scheme that recalls Max Ernst's provocative patterned rubbings taken from grainy surfaces.

Ten Haeff's amoeba-like forms, surrounded by multiple dissolving halos or echoes, invite several interpretations. *Klingsor's Garden*, *Corona* and *Kosmische Blume No. 2* are good examples of how they seem to be testing the power of symbolic forms and the strength of iconic images, and they also underscore the meanings implied by an uncanny eye—almost an anthropomorphized blossom in these instances. Associations with the Surrealist interest in organic imagery as an expansion to other realms, including the cosmic, are valid too. One of ten Haeff's largest works from 1965, *Family and Orbs*, might be regarded a summary of her exploration of cosmic qualities and of the reinterpreted bottle-object as well.

In treating her amoeba-like motifs, ten Haeff frequently employed thinner applications of pigment. This technique permits suggestions of color and matter to emerge beneath the primary surface. The references to hidden mysteries are in line with Surrealist principles, and the veiling concept recalls processes occurring in both Surrealism and later, in very special ways, in New York abstraction.

Much of the impact in ten Haeff's work derives from her use of space. The dynamic achieved early on, with a gigantic bottle contour (her metaphor for a human being) thrusting beyond the canvas, seems related to Gauguin's ambiguous pictorial spaces which serve not as windows or boundaries but as flat, totally creative surfaces that imply continuation on the adjacent wall or in the viewer's own area.

Post-impressionism and subsequent Cubist traditions—particularly the understanding of a painting as an independent arrangement on a flat surface—are basic to the spatial steps that ten Haeff started to investigate further and use almost exclusively by 1965. At this point, flat,

faceted units begin to characterize the paintings. There is a sense of interconnected, interlocking rhythms based on shape, tone and placement. Components within the work establish multiple internal dialogues that create energy, action, and often visual tension. Geometric units are contained within their own sections, or compartments in *Man's Voyage No. 4* implying some balance between chaos and order. Numerous irregular fragments in *Overshadowings* may comment on a fractured world.

Faceted, compartmentalized space takes on architectural qualities in the massive paintings like *Death Giving Birth*. When it totally fills the observer's vision, scale can be both disorienting and absorbing, allowing the work to establish a mood. With a large format, the niche-like compartments lend Gothic overtones, and the bold divisions of color have the aura of stained glass.

Bold, geometric spatial divisions are also characteristic of the *Hanger* series, a 1966 diversion that reasserts the potential of fantasy. The coat hanger contour, in single and double units, turns into personified, almost shamanistic objects with implied heads, arms, curving birdlike or snakelike top appendages, and occasionally a suggestion of splayed legs. Sometimes cosmic circle motifs are positioned to signify breasts as well as a sun or moon. The heightened color and the character of the crisp patterning suggest qualities of American Indian designs, further underscoring the spirit of magic. The omnipotent eye motif also appears frequently.

Ten Haeff next addressed the question of merging avant-garde ideas about space, form and abstraction with concepts of portraiture. It is a challenge that intrigues many artists. She chose to work with frontalized faces that fill the surface and push forward—an approach used by the early twentieth century Russian/German painter, Alexej von Jawlensky, who expressed personality through bold units of color. Ten Haeff, an admirer of Jawlensky, continued her recently developed vocabulary of circles and irregularly shaped, interlocking rectangular facets, however, and made the analytical nature of maze-like surface faceting into a metaphor for revealing personality. Eyes, of

course, are important to all ten Haeff portraits, and major examples like *Head: Architect* and *John of the Cross* have more than a single pair. Significantly, her own self-portrait is softly blurred, as if the subject was difficult to define. Aggressively pressuring the canvas borders, its all-white surface and emphasis on the power of contour recalls the earlier monochromatic paintings in the bottle series.

To a very contemporary, 21st century eye, the heads characterized by crisp, flat interconnected patterns seem to have anticipated art that brings in the relevance of technological schematics and interface wirings. At the time, however, ten Haeff would have regarded her figurative creations as "humanoids," perhaps choosing a modern perch for a broad summation of mankind.

Ten Haeff's investigations of human personifications, real and fanciful, have proven to be a long-term and deeply felt direction. Her *Janiceps* series from the Seventies features centrally placed, flatly painted, double-headed figures that relate to the legend of Janus, the ancient king of Italy who is always depicted with two faces looking in opposite directions because he was said to know both the past and the future. The legend is sometimes used to refer generally to duality, signifying all pairs of opposites. Ten Haeff sees the series as an expression of the natural split in the characteristics of all people. There is a certain universality to the theme that has a kinship with interests of other 20th century artists, especially the surrealists who were intrigued with the myths of all cultures.

Many regard ten Haeff's *Chiromancy* series as a summation of her intuitive and intellectual insights into human beings. Dating from 1979, these highly elaborate images in graphite pencil, ink, and colored pencil are based on tracings of the hands of specific individuals and take their title from the ancient practice of divination by examination of the hand. While chiromancy has old and multi-cultural roots, ten Haeff's complex but perky reuse becomes an opportunity to explore an original, creative avenue that brings in fairly substan-

tial content and in this sense goes beyond primarily abstract modes. Psychological probing and spiritual symbolism become part of this content, and there are clear links to the Surrealist predilection for revealing what is not always readily visible.

The dominant spirit in these chiromancies is one of fantasy. At times it is possible to imagine abbreviated faces or animal heads emerging from the fingertips, or a cosmic sign, eye or landscape in the palms. The fantasy is reinforced by the flat renderings and crisp delineations of geometricized—but totally unpredictable—fractures that had already characterized ten Haeff's expressive vocabulary for more than a decade. Busy patterning makes the hands appear animated, but at the same time the pencil strokes lend delicacy. The inherent intimacy provided by pencil markings seems to enhance the personal nature of the hands.

Much of the sense of animation that seems so appropriate for hands also comes from the overlapping and superimposition of their multiple tracings. The positioning contributes, too, especially the way the fingers activate their surrounding space on the drawing sheet. Gestures are also very important, and these are not so much depicted as invented. There can be a considerable sense of the theatrical.

The effectiveness and success of this series, which involves participants with celebrity status in the worlds of art, architecture, theater, music and literature, derives in part from the somewhat uncanny combination of coming so close to the respected individual through their hands and the authority of the line, yet finding the persona interpreted so fancifully. In addition, there is that added thrust of studying hands that are themselves used in a creative process.

In retrospect, ten Haeff's pencil-based chiromancies may have been an inevitable course, for she had always shaped her ideas by drawing. These drawings, produced over decades, make .a rewarding independent study. Pieces from the Sixties reflect a very wide range. *Gefangen Gesucht*, with its single large shape set off by compartmentalizing that extends to each edge, emphasizes angularity and an all-over definition of the surface. Another dynamic example, untitled as are most ten Haeff drawings, uses multiple, superimposed thin lines in a centralized unit to imply animated mass, and a third work demonstrates how bolder, nervous marks can seem to function as separate forms that electrify space in an emotionally descriptive way.

There are drawings from the Seventies that reflect ten Haeff's interest in extensively faceted portrait heads. These seem, in part, to be comments on the complex nature of individuals. Many other examples relate to her involvement with the Janus theme. At times the experience is reduced to a pared-down, synthesized suggestion of figurative forms. In other instances, schematic patterning becomes part of the concept.

The range of ten Haeff's approaches to the practice of drawing is particularly broad in examples from the Eighties. One example is a careful study of mass and void; another tests the way brief ink strokes can suggest a figurative mass; and still another Eighties figurative study—one that recalls de Kooning's drawings—seems to demonstrate a rapid, intuitive response to the subject. These studies do much more than support the significant directions ten Haeff has explored. They underscore the solid probing that is characteristic of her long career. □

—— PHYLLIS BRAFF

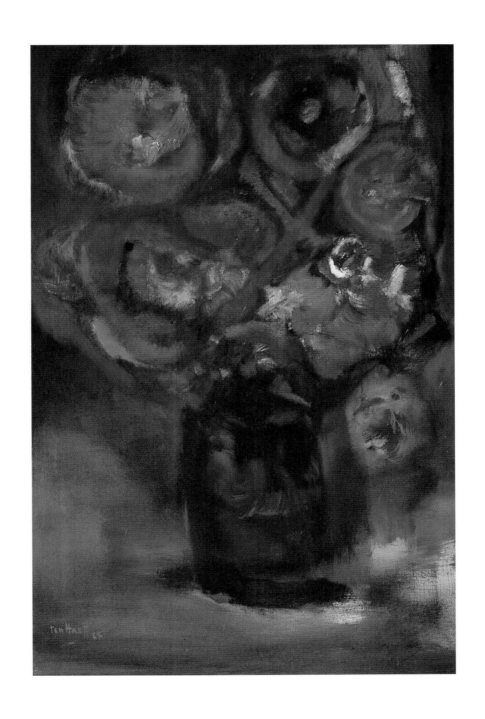

Untitled, 1964
Oil on canvas, 36 x 24 inches

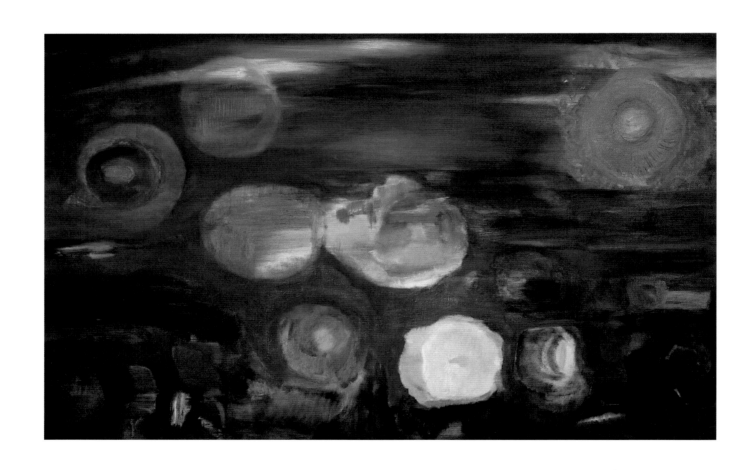

Seascape, Skyscape, 1962
Oil on canvas, 38 x 64 inches
Collection Sra. Clara Brillembourg, New York

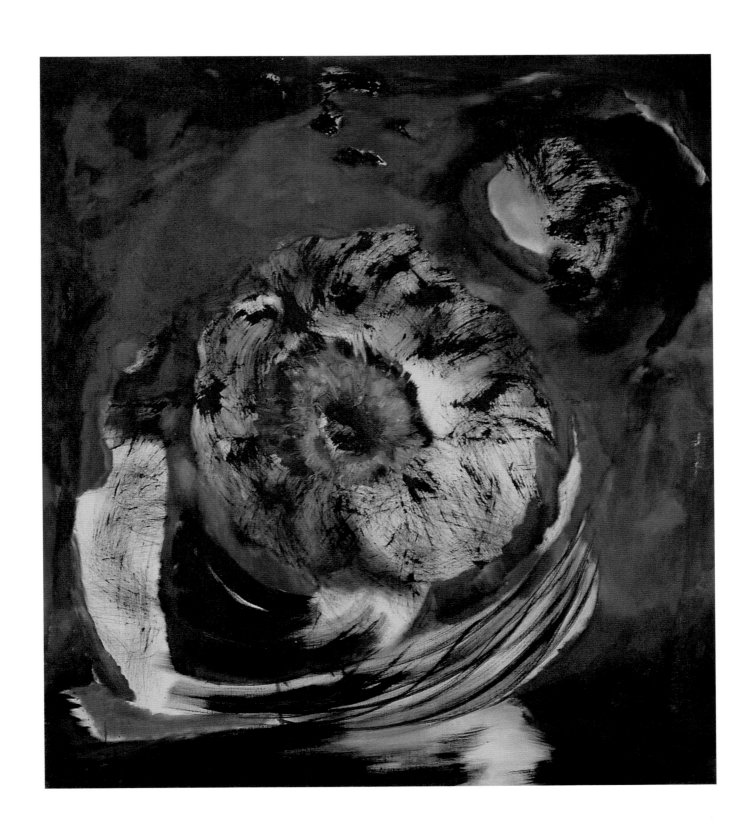

Klingsor's Garden, 1963
Oil on canvas, 53 x 48 inches

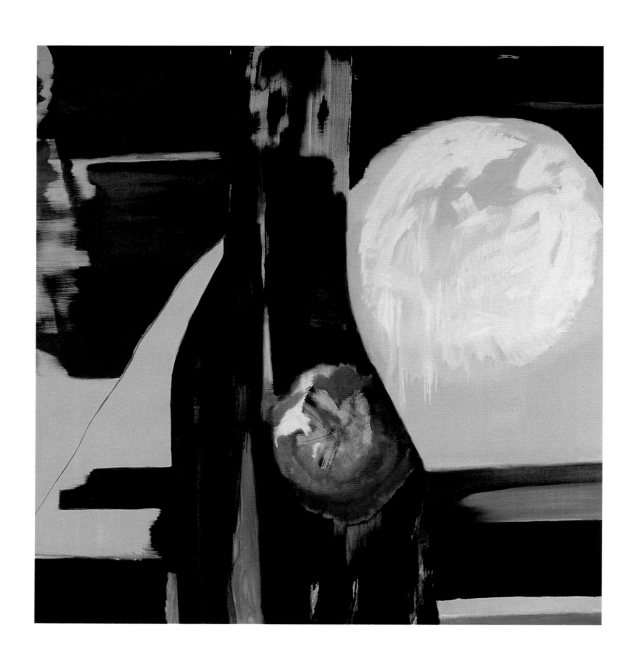

Der Einzelne, 1962
Oil on canvas, 76 x 72 inches

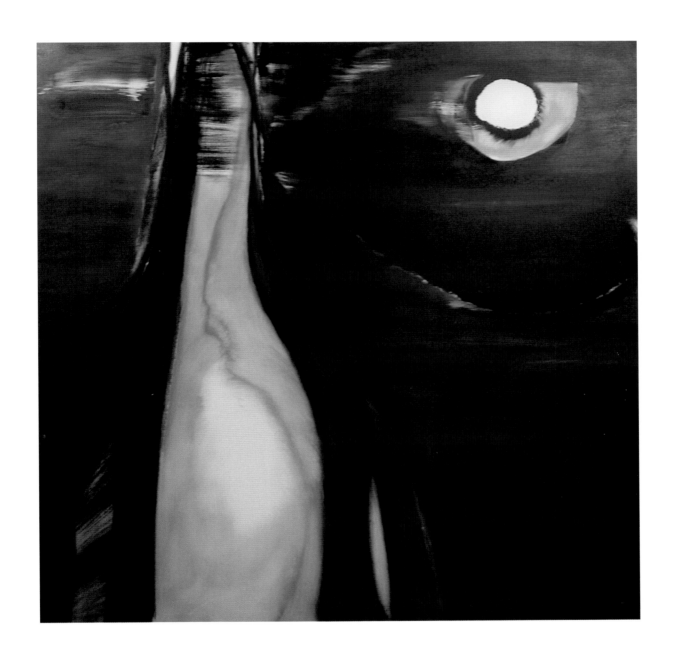

Silence, 1962
Oil on canvas, 60½ x 60½ inches

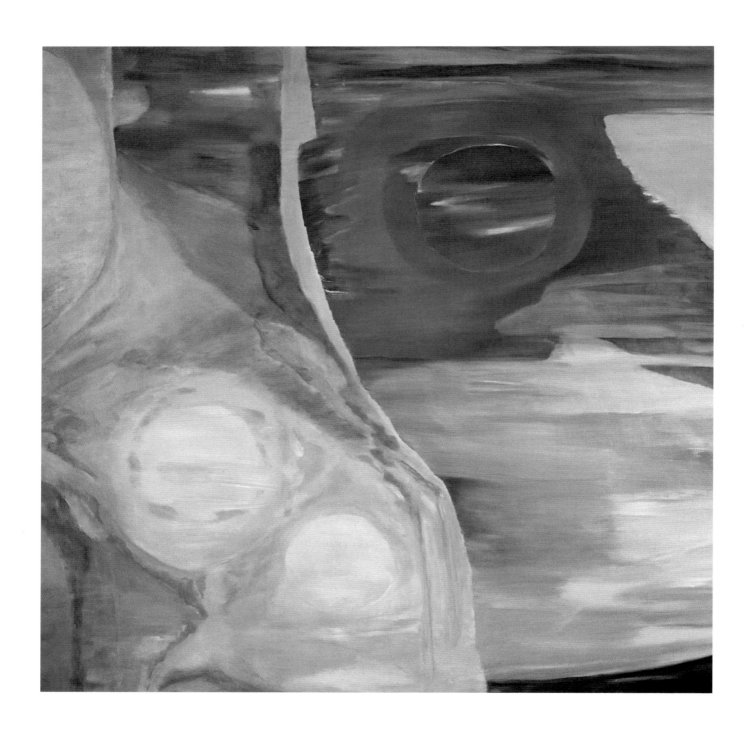

Dark Sun, 1961
Oil on canvas, 71½ x 71½ inches

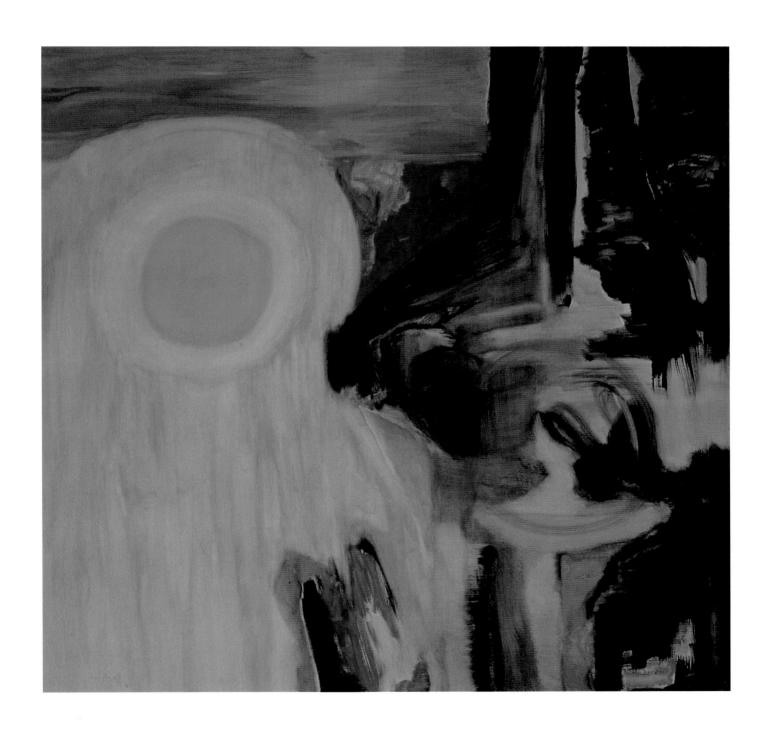

The Wounded Bride, 1961
Oil on canvas, 72 x 72 inches

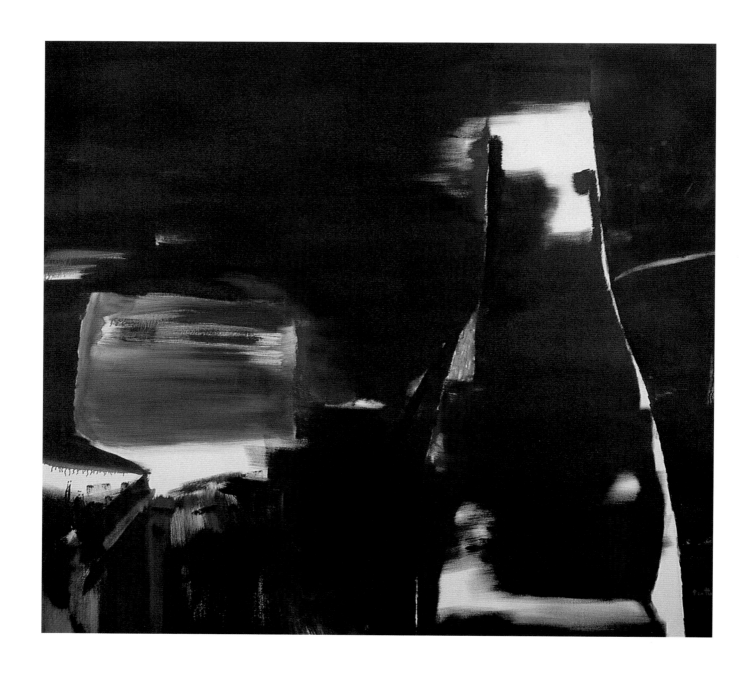

Aware, 1963
Oil on canvas, 70½ x 84 inches

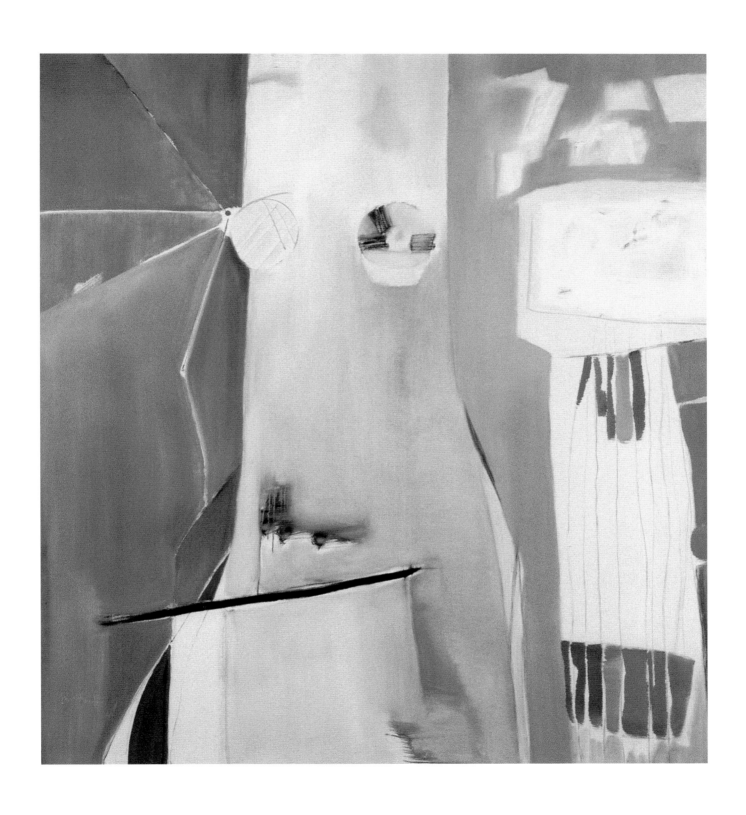

Orpheus and Euridice, 1964
Oil on canvas, 75 x 72 inches

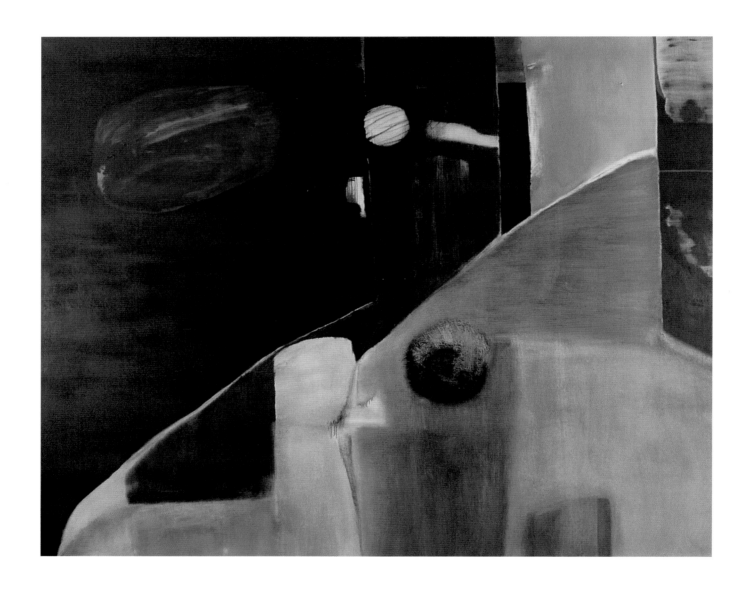

Family and Orbs, 1965
Oil on canvas, 76 x 94 inches

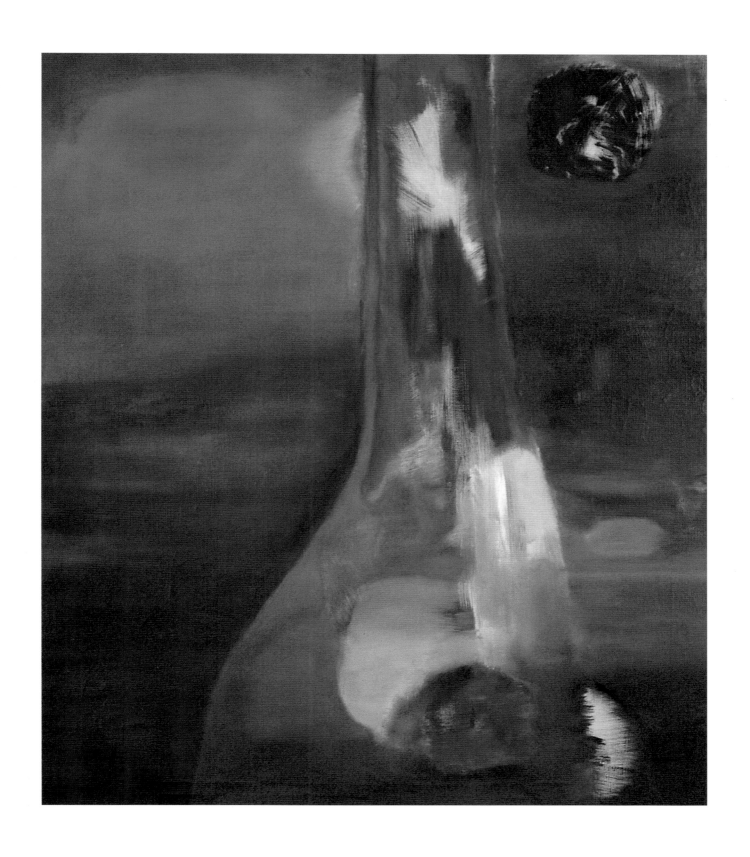

Untitled, 1961
Oil on canvas, 47 x 41 inches
Collection of Joan K. Davidson

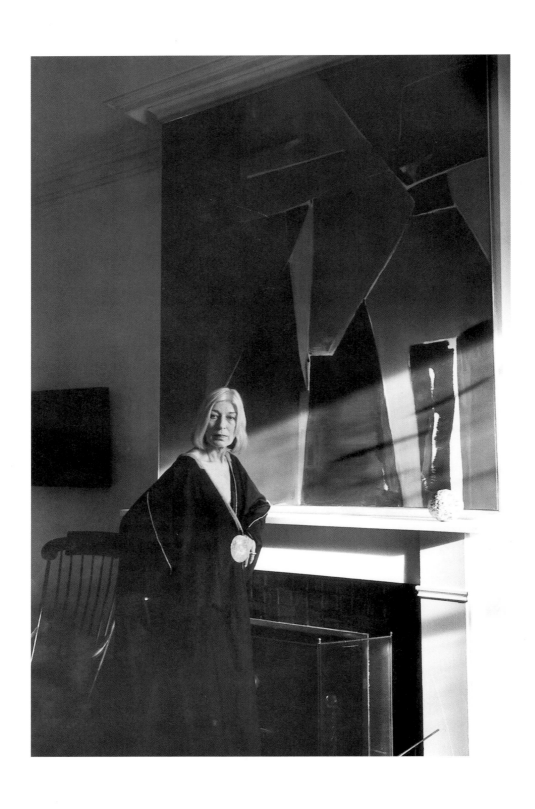

Photograph by Inge Morath, 1980

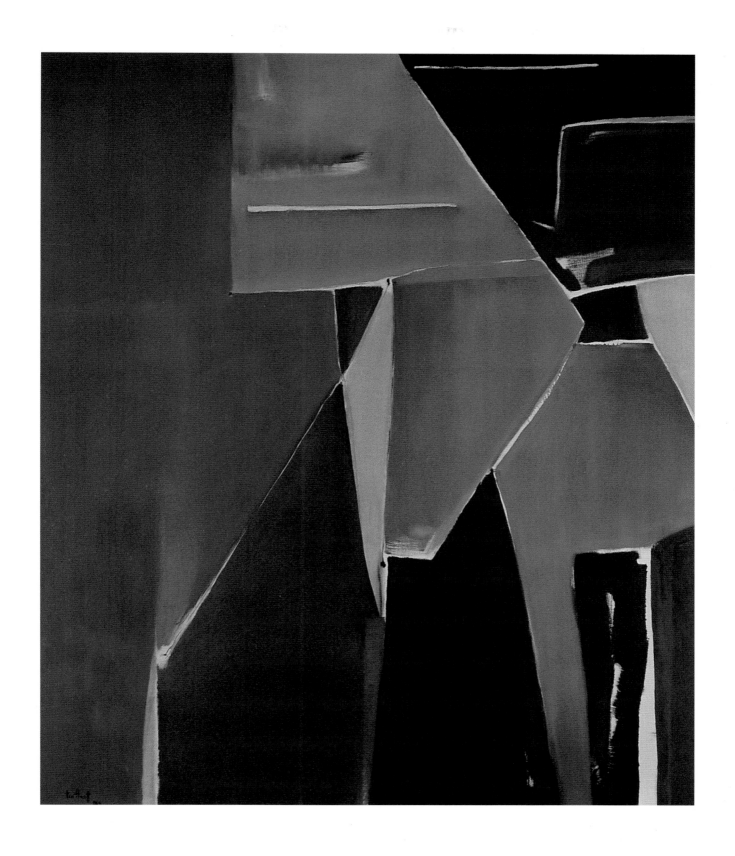

The Couple, 1964
Oil on canvas, 84 x 72 inches

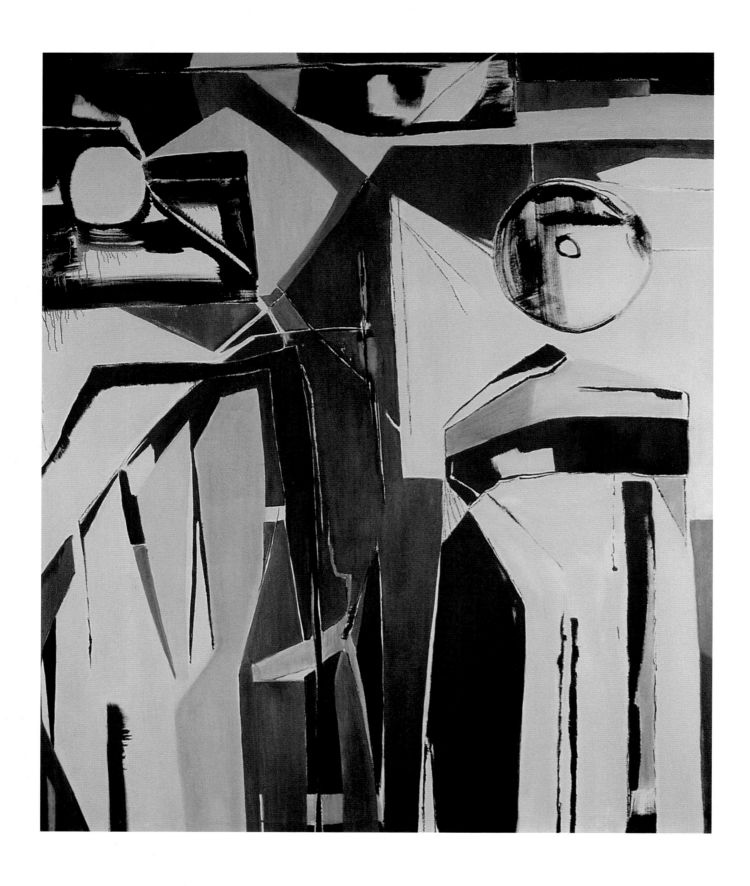

Overshadowings, 1965
Oil on canvas, 84 x 72 inches

Untitled, 1985
Crayon on paper, 16 ¾ x 13 ⅞ inches

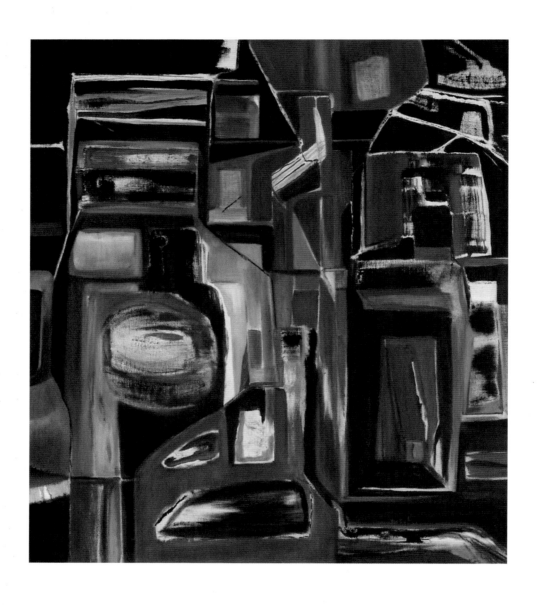

Untitled, 1968
Oil on canvas, 42 x 38 inches
Collection of Hilton and Esta Kramer

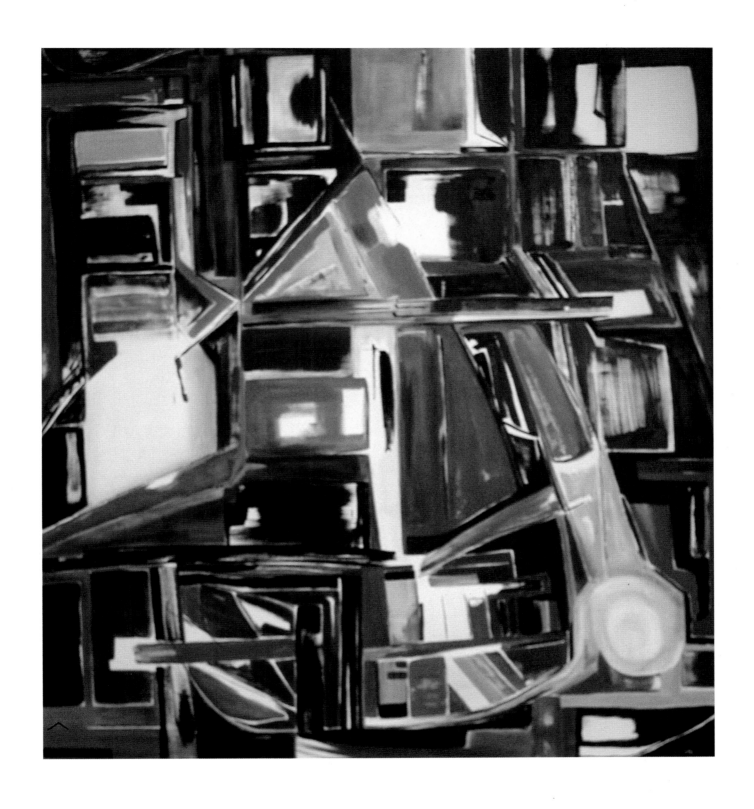

Death Giving Birth, 1968
Oil on canvas, 85 x 79 inches

*Gefangen Gesucht.*1966
Pencil on paper, 17 x 13 ¾ inches

Installation of ten Haeff exhibition at the
Hudson River Museum, 1969

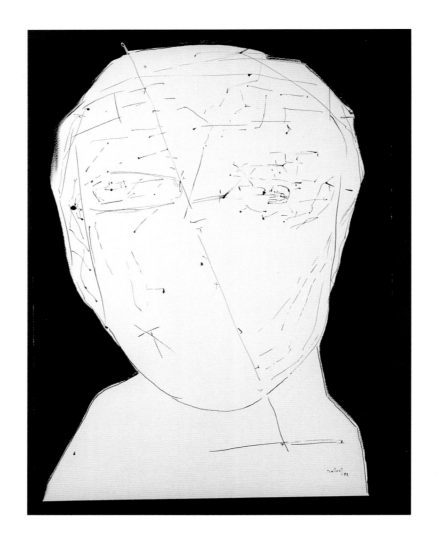

Untitled, 1973
Ink on paper, 23 ¾ x 18 inches

Self Portrait, 1969
Oil on canvas, 62 x 42 inches

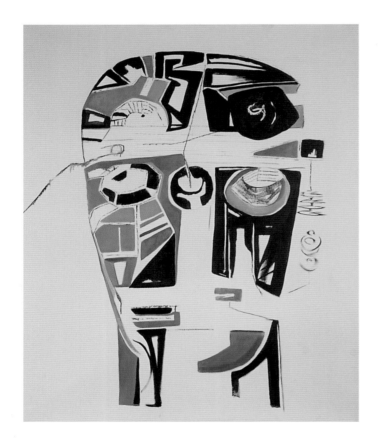 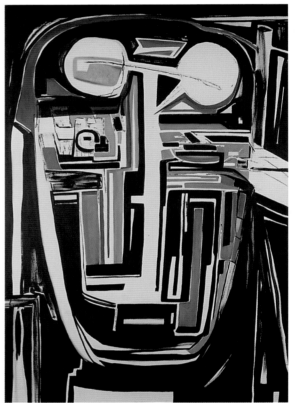

Left: *John of the Cross,* 1969
Oil on canvas, 48 x 41 inches

Right: *Head: Architect,* 1968
Oil on canvas, 61 x 42 inches
Collection of Carlos Brillembourg

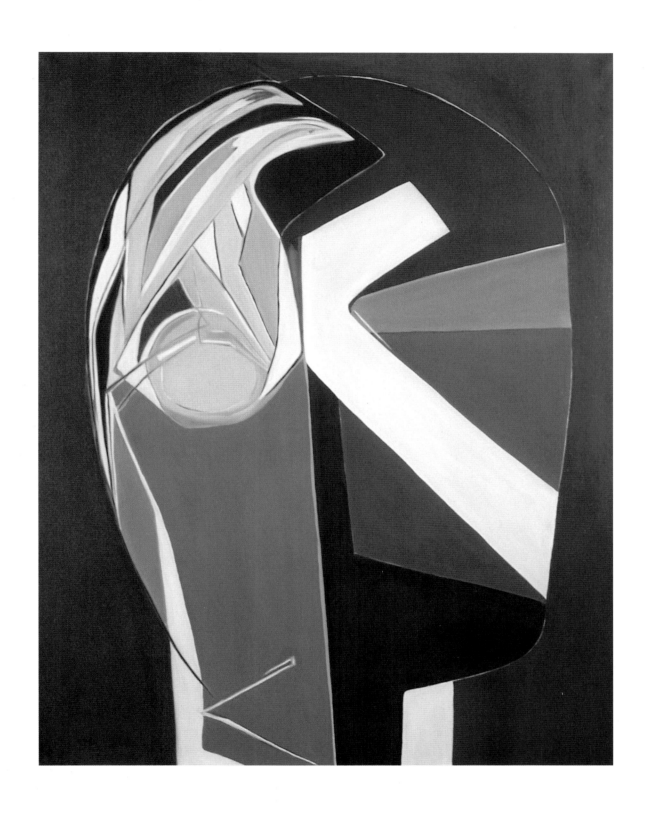

Portrait of Candida, 1975
Oil on canvas, 45 x 35 inches

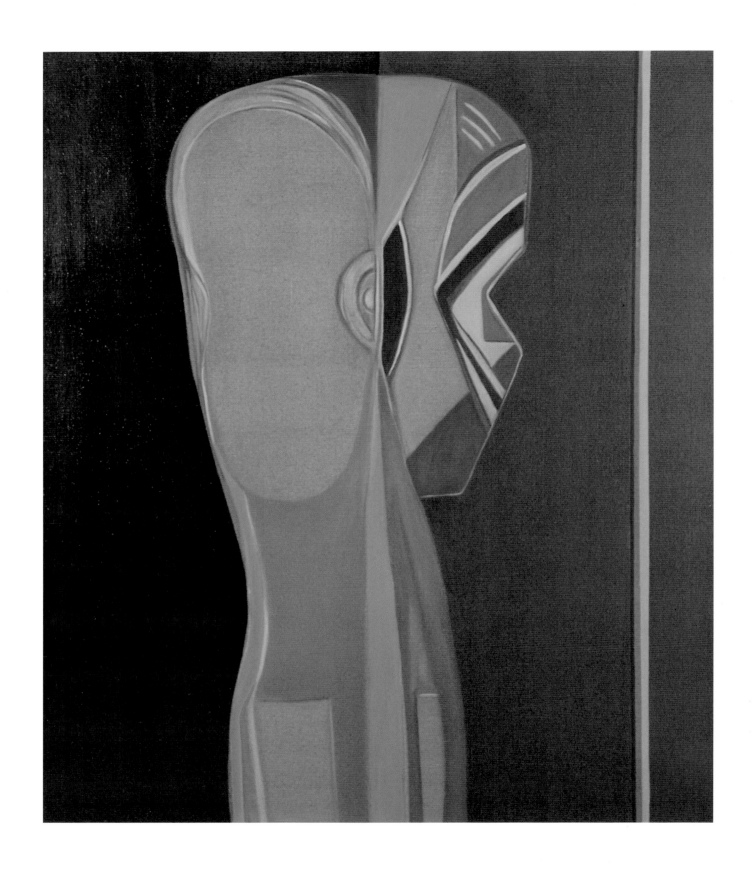

Janiceps Series, 1976
Oil on canvas, 28 x 24 inches

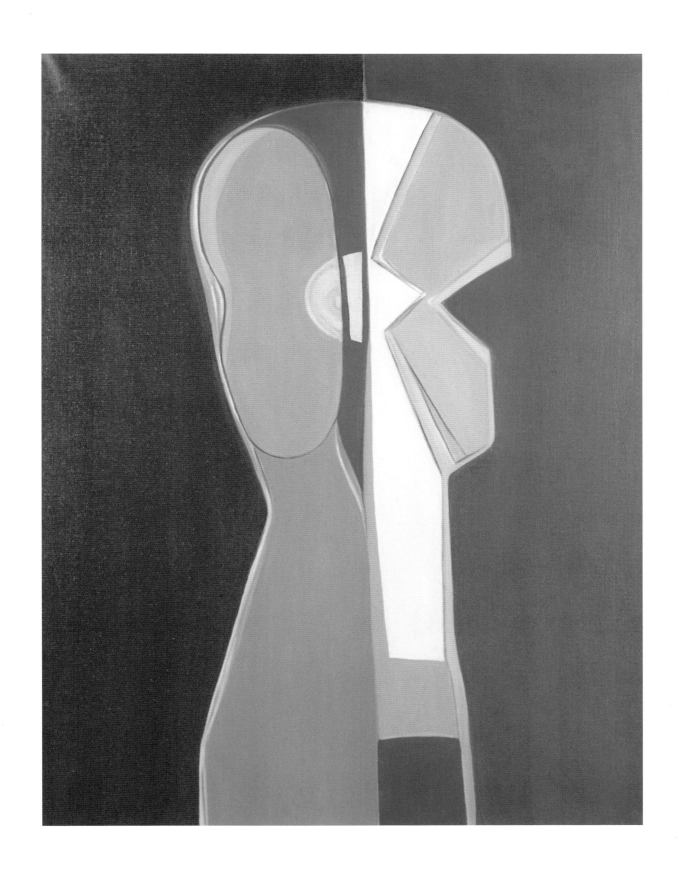

Janiceps Series, 1976
Oil on canvas, 30 x 23 inches

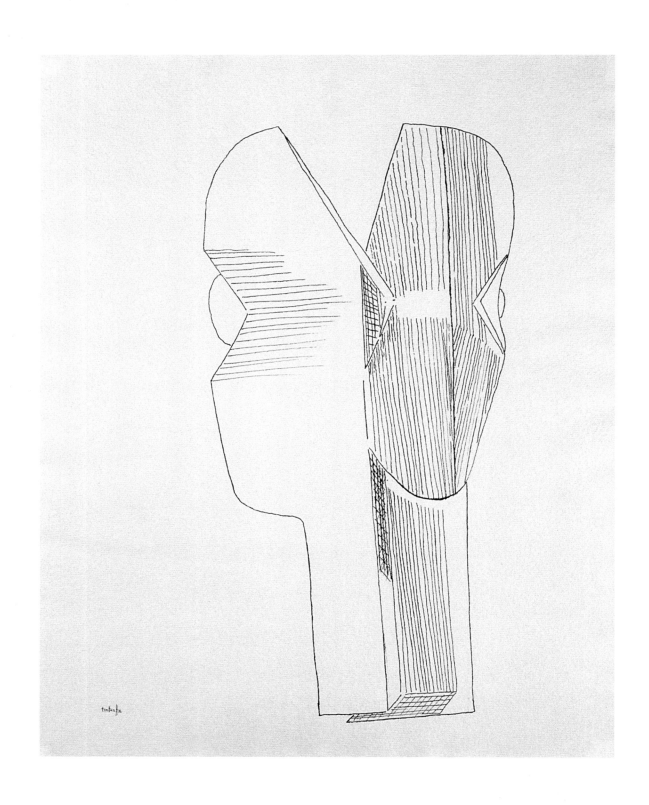

Janiceps Series, 1976
Ink on paper, 17 x 18 ¾ inches

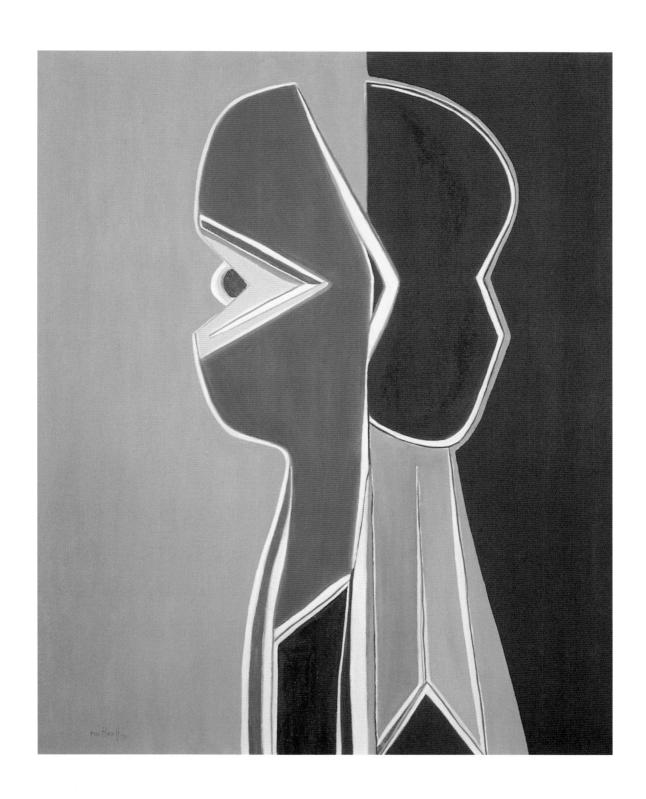

Janiceps Series, 1976
Oil on canvas, 30 x 24 inches

49

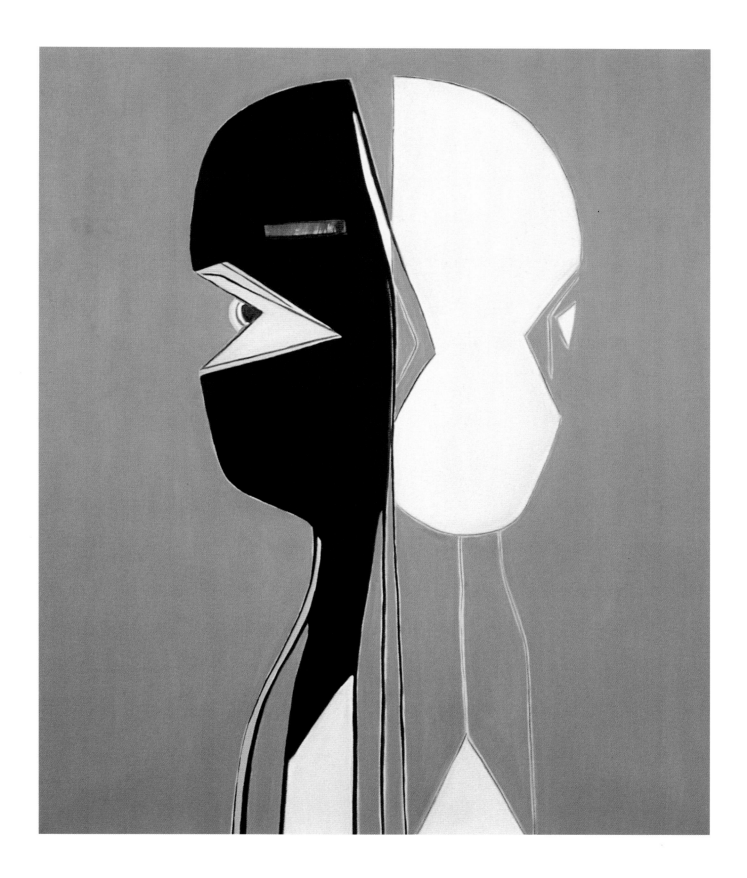

Janiceps Series, 1976
Oil on canvas, 30 x 25 inches

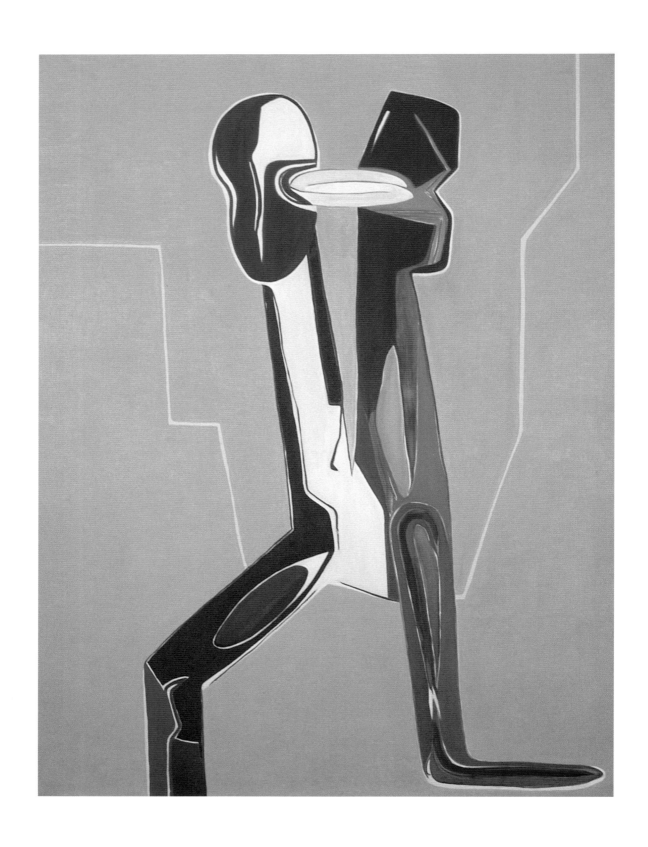

Janiceps Series: Split, 1976
Oil on canvas, 40 x 30 inches

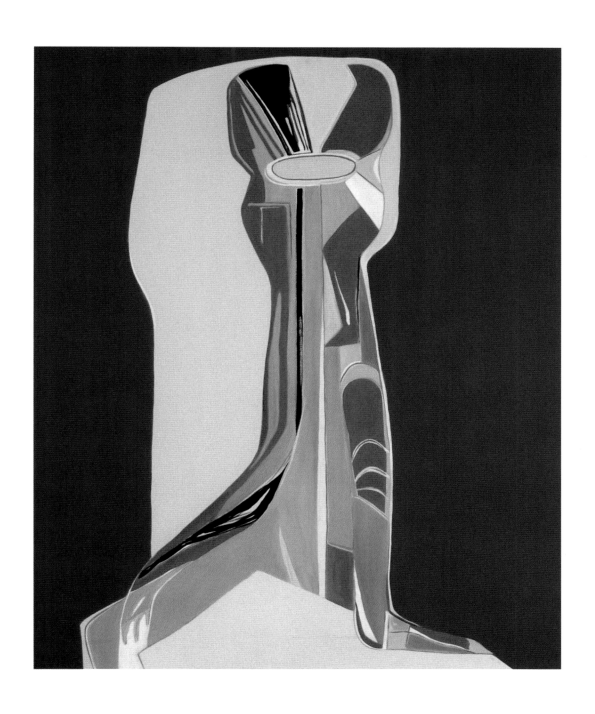

Janiceps Series, 1976
Oil on canvas, 48 x 39 inches

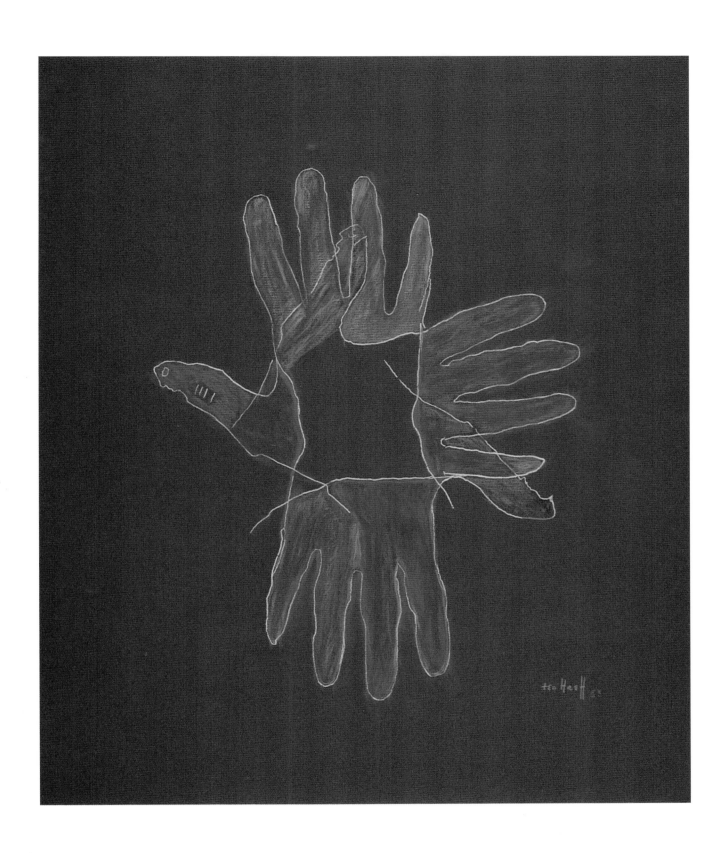

Chiromancy Series: Willem de Kooning, 1983
Color pencil on color board, 19 x 16 inches

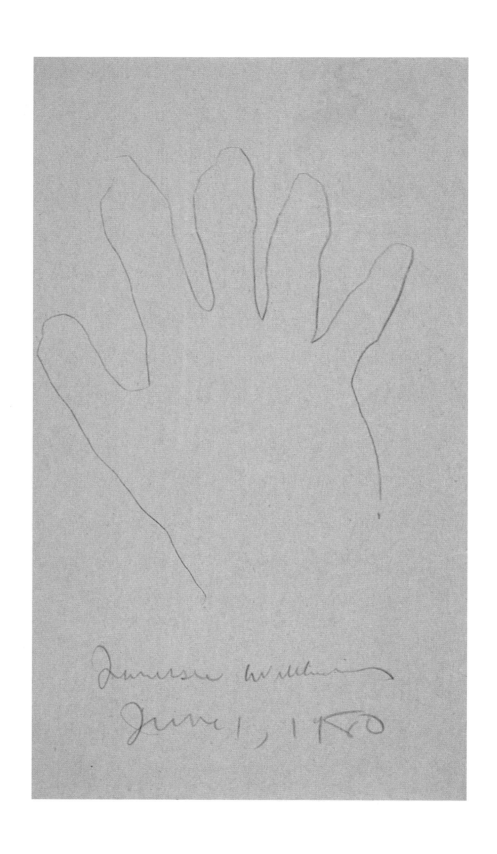

Chiromancy Series: Tennessee Williams of his own hand,
signed and dated 1 June, 1980
Pencil on tracing paper, 14 x 8 inches

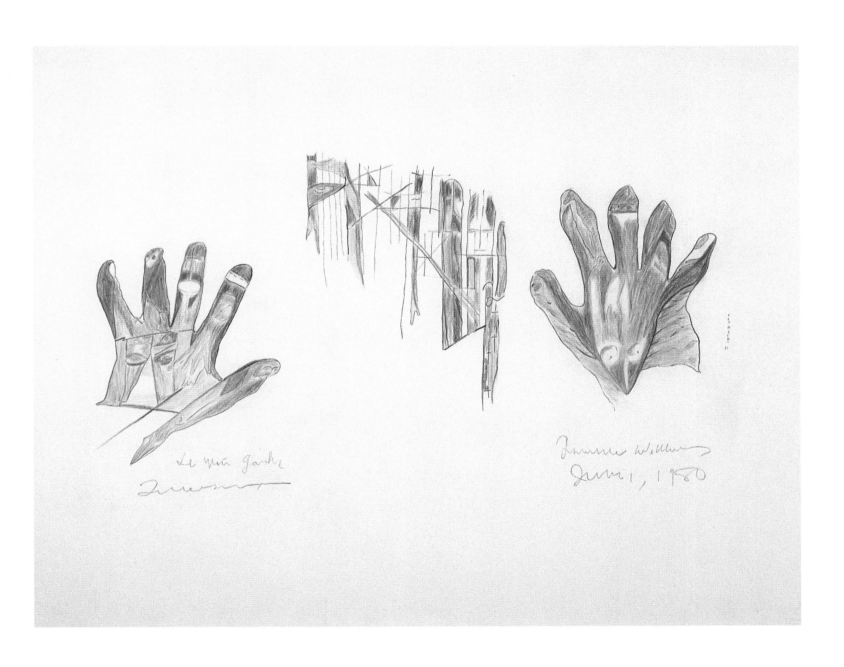

Chiromancy Series: Tennessee Williams, 1981
Pencil, color pencil on paper, 22 x 30 inches

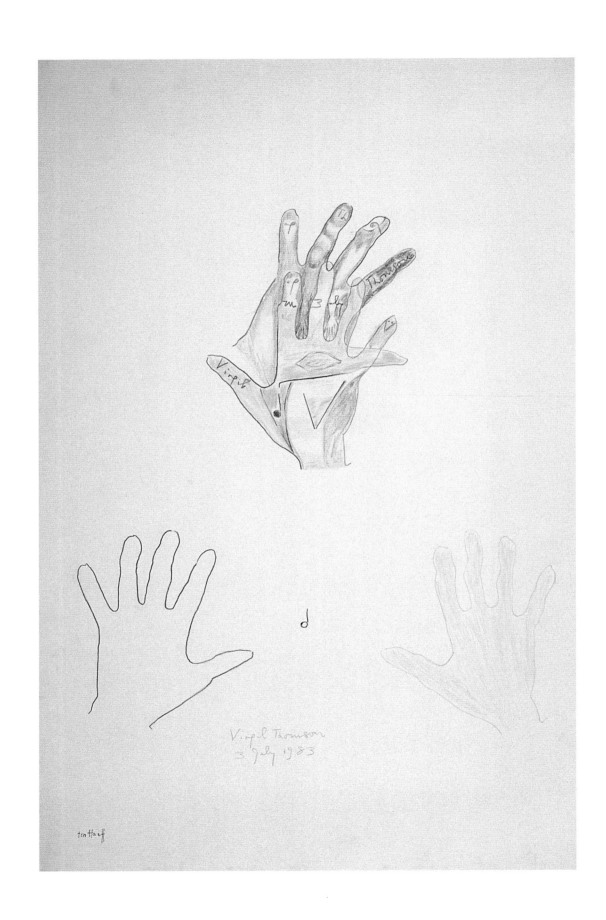

Chiromancy Series: Virgil Thompson, 1984
Pencil, color pencil on paper, 30 x 22 inches

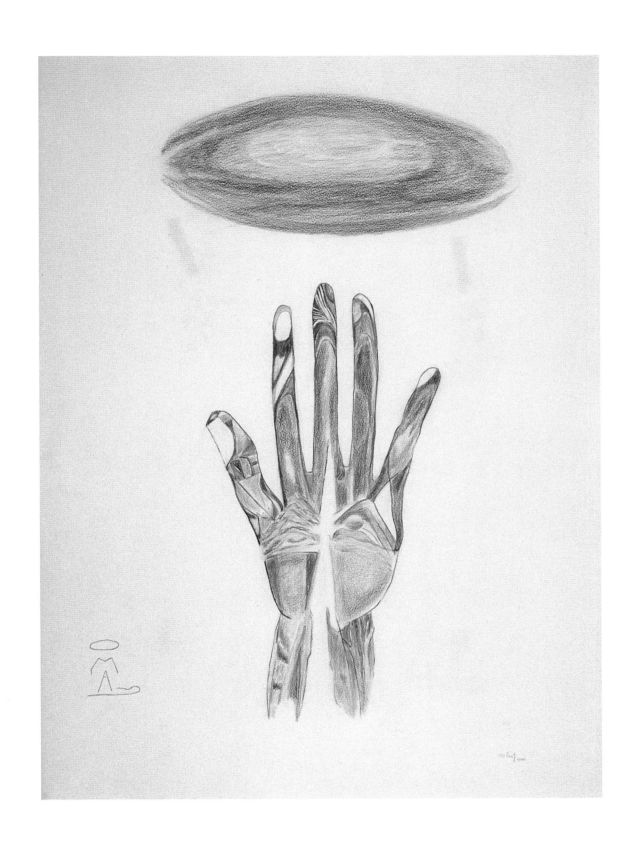

Chiromancy Series "Omar": Herbert Bayer, 1980
Pencil, colored pencil on paper, 30 x 22 inches

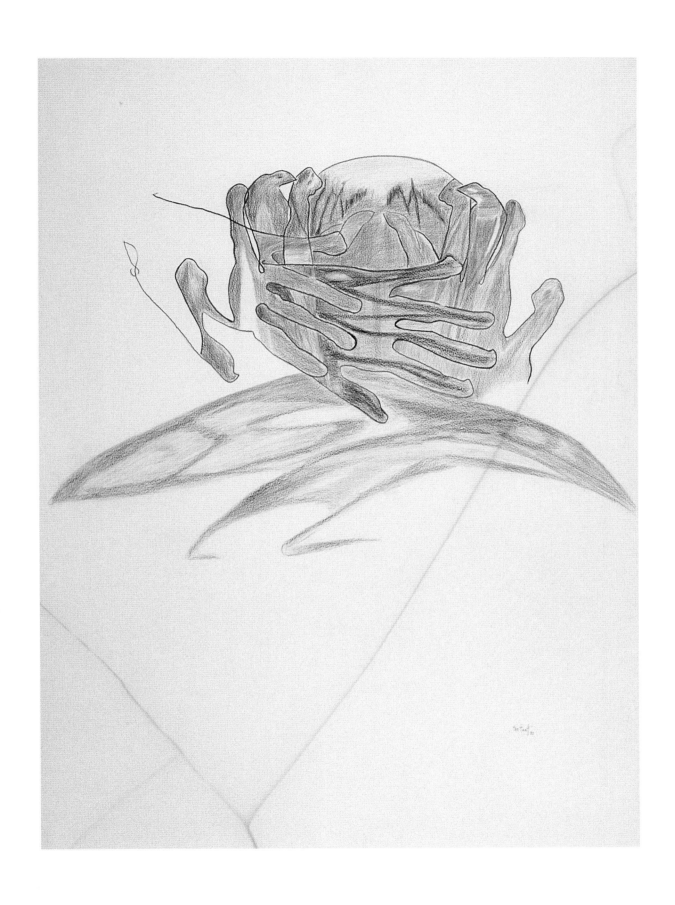

Chiromancy Series, Balcomb Greene, 1980
Crayon and color pencil, 30 x 22 inches

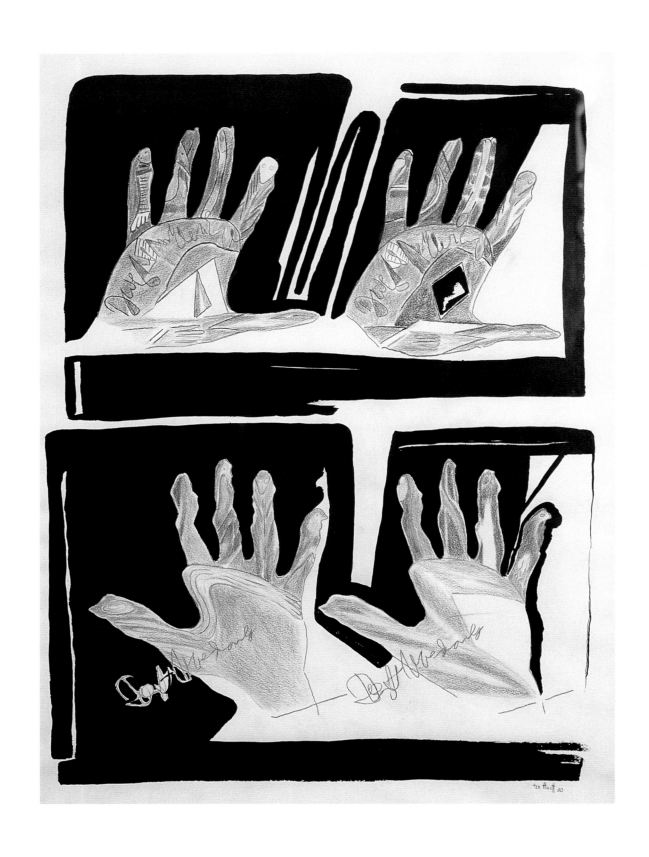

Chiromancy Series: Dwight Macdonald, 1980
Ink, pencil, color pencil on paper, 29 x 20 inches

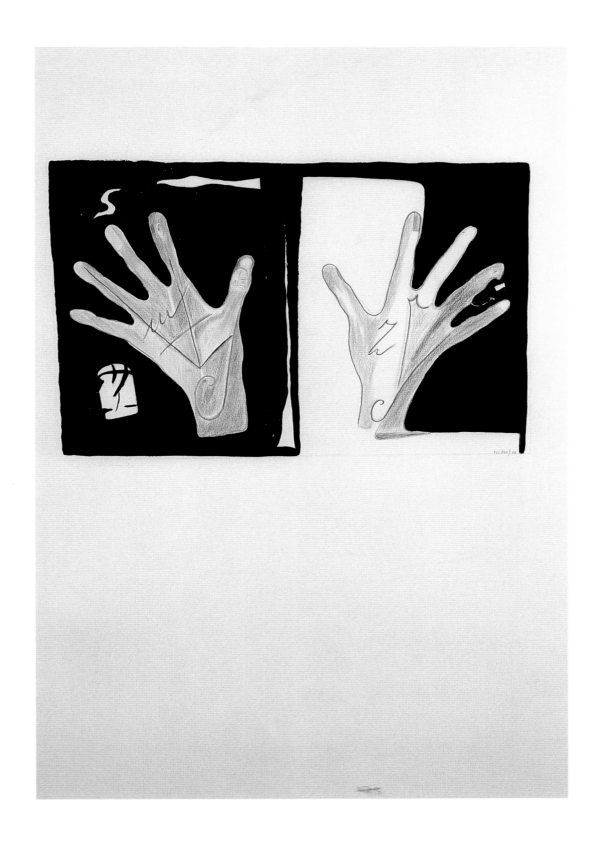

Chiromancy Series: Camelia Riso, 1979
Ink and color pencil on paper, 30 x 22 inches

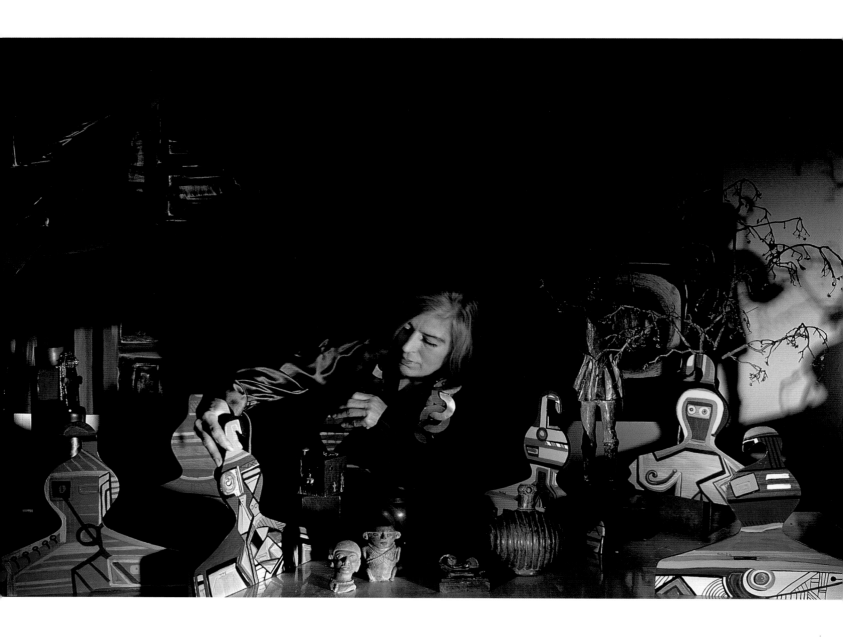

Ten Haeff with "Hanger Series" in her Amagansett Studio, 1966
Photograph by Adelaide de Menil

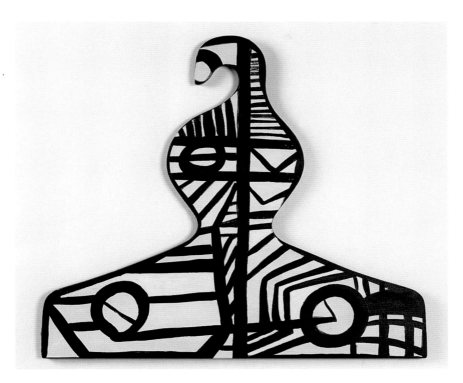

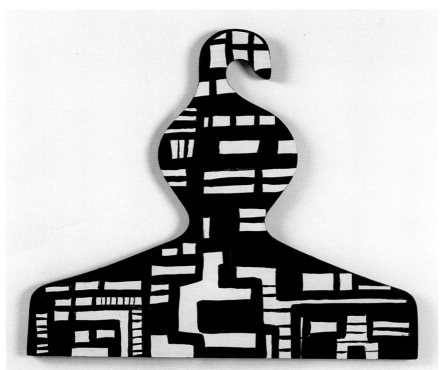

Top: *Hanger Series,* 1966
Acrylic on plywood, 14 x 16 inches

Bottom: *Hanger Series,* 1966
Acrylic on plywood, 14 x 16 inches

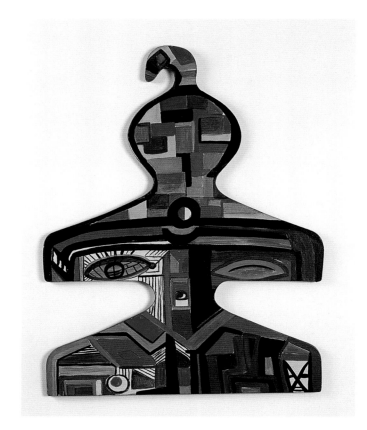

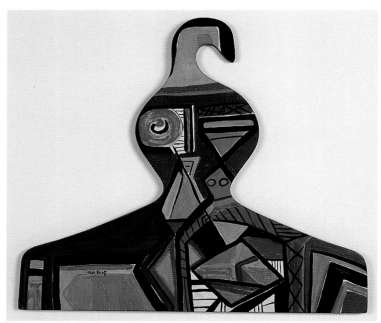

Top: *Hanger Series,* 1966
Acrylic on plywood, 21 ½ x 16 ½ inches

Bottom: *Hanger Series,* 1966
Acrylic on plywood, 14 x 16 inches

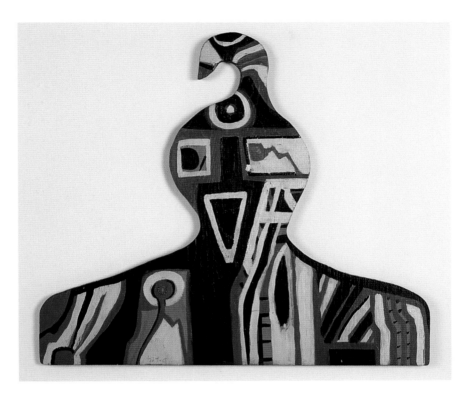

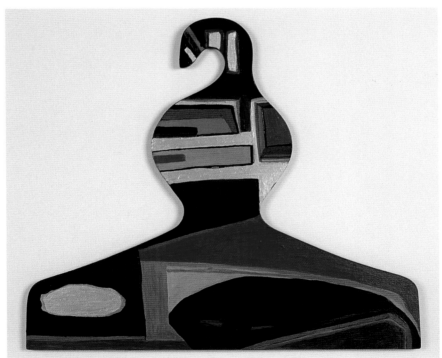

Top: *Hanger Series,* 1966
Acrylic on plywood, 14 x 16 inches

Bottom: *Hanger Series,* 1966
Acrylic on plywood, 14 x 16 inches

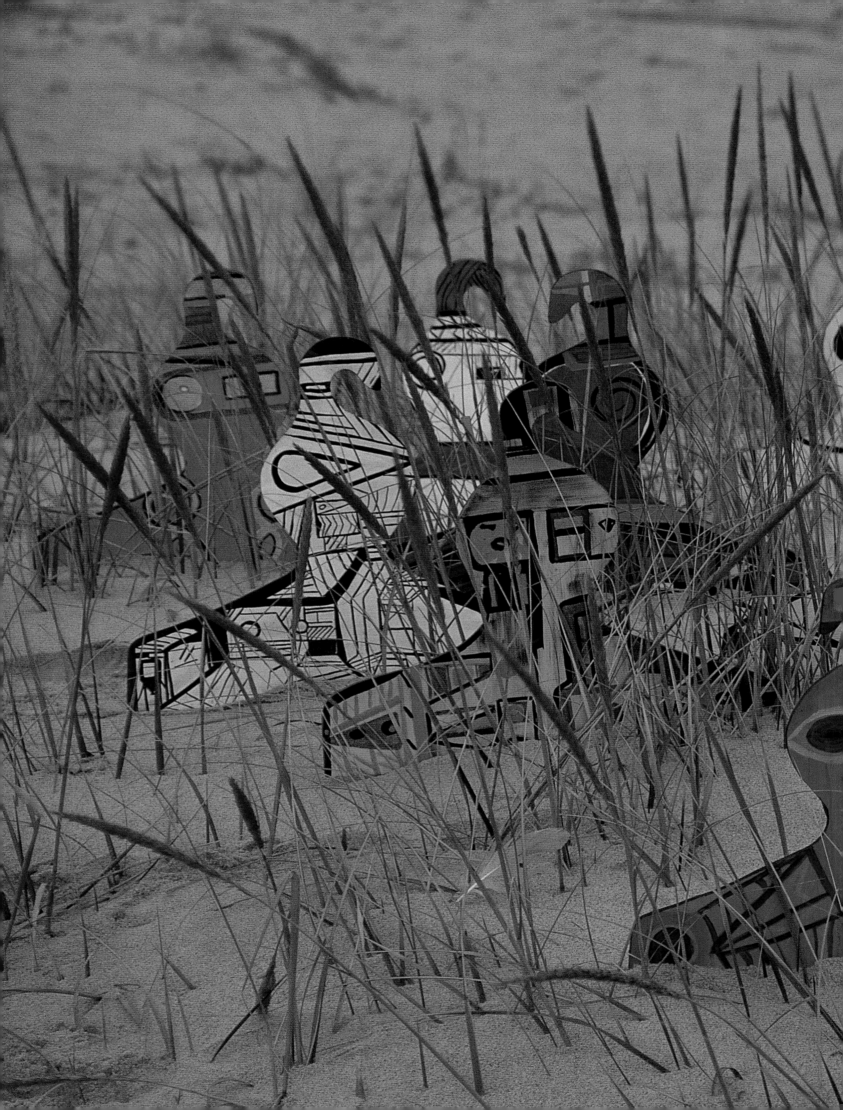

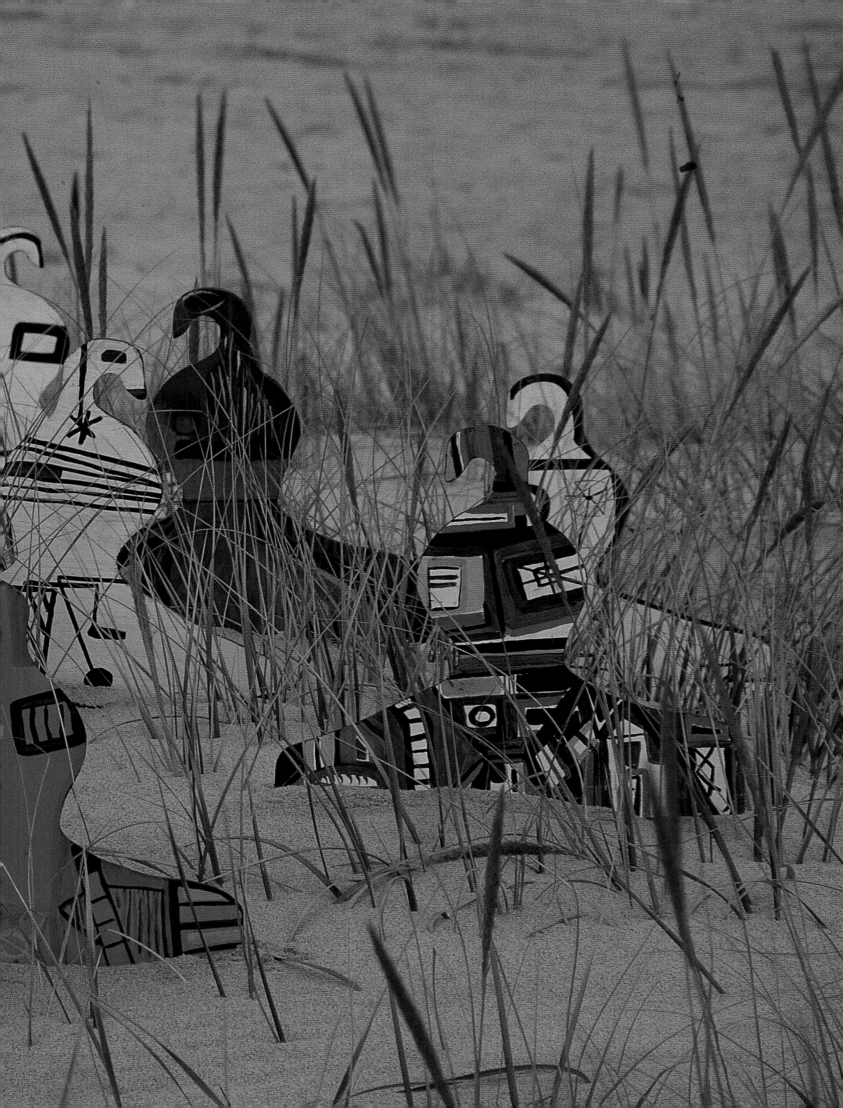

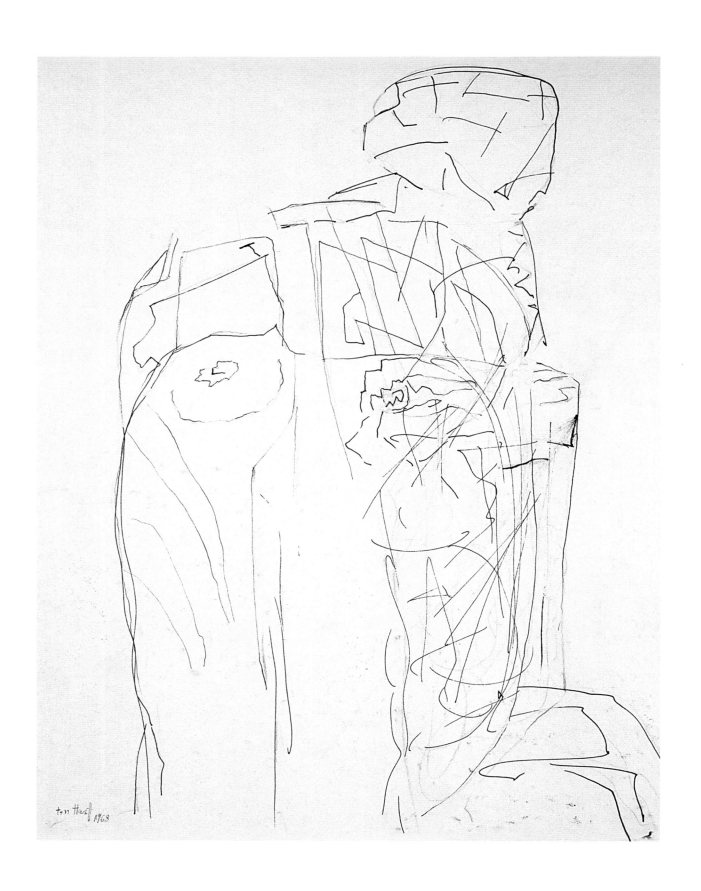

Preceding pages: *Hanger Series in the Amagansett Dunes*, 1966
Photograph by Adelaide de Menil

Untitled, 1968
Pen and ink on paper 14 x 19 inches

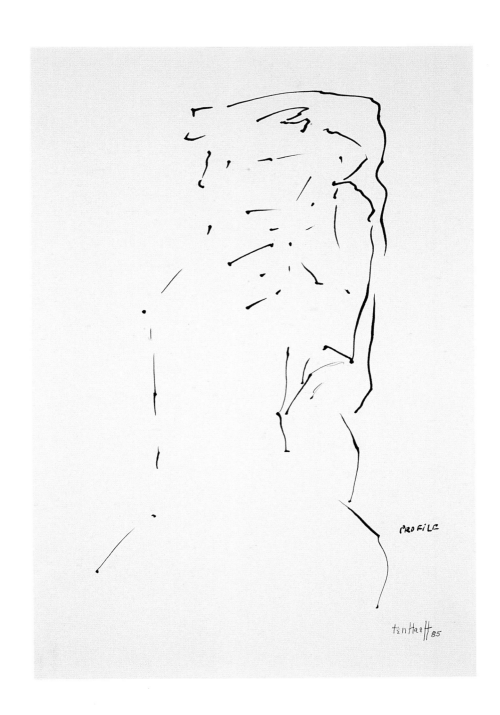

Profile, 1985
Pen and ink on paper, 14 x 10 ½ inches

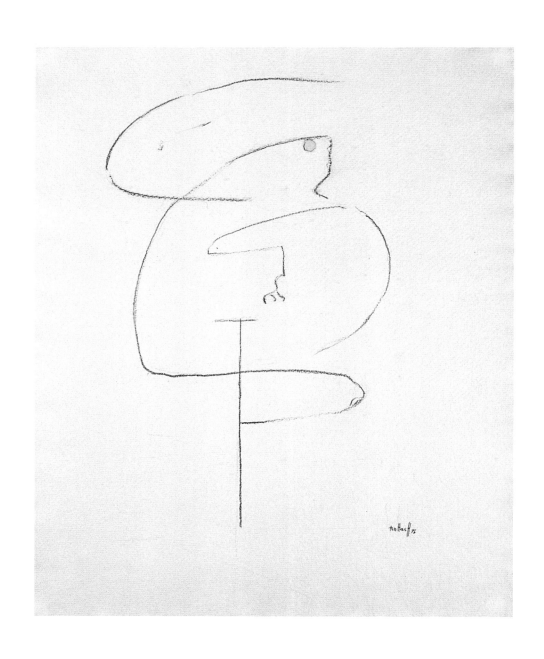

Untitled, 1976
Pencil on paper, 17 x 13¾ inches

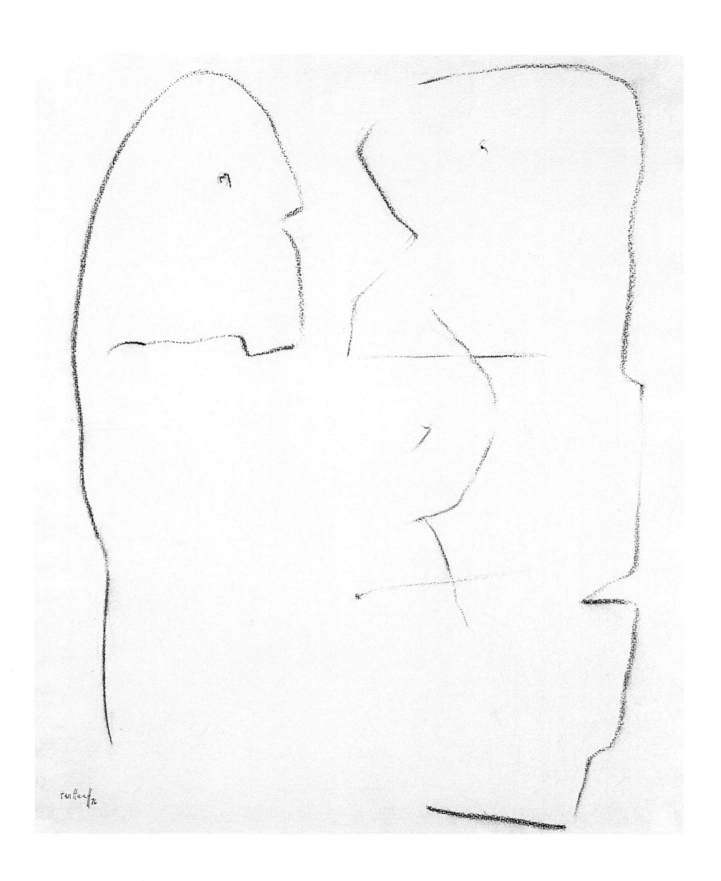

Untitled, 1976
Pencil on paper, 17 x 13¾ inches

25 Washington Square North

afterword

Ingeborg ten Haeff is a seeress who dwells in our time but perceives it seemingly from another realm. The story of her life is like a novel that sweeps across half the world and most of a century, replete with history, romance, adventure, and art. Few individuals can have known so many interesting people, visited so many interesting places, practiced so many arts, and lived such extremes of discovery, attainment, loss—and then (the secret of eternal youth) rediscovery, renewed fascination with new places, new people, new art forms.

Here and now in 21st-century New York City—Washington Square North, in an apartment she and her scholar husband have filled with treasures from the artists they befriended and the lands they traveled—Ingeborg projects, nonetheless, a presence that belongs to no particular era or place. In bearing and attire she could be an ancient priestess or an actress on some faraway eso-

teric stage. The way she dresses, ceremonial yet celebratory, is itself an art form, strikingly composed from fabrics and ornaments collected the world over. Like her surroundings, it expresses something of her inner essence, and in conversation she seeks out such an essence in others. Whomever she meets, she regards with her mind's eye, and what she finds cannot always be expressed in words, though often it has emerged as image.

The art, like the artist, may seem otherworldly and mysterious, but it is rooted in keen experience and perception. Rendered with an acute sense of line and color, it delves beyond surface identity to limn the nature of a personality, aspiration, dilemma, emotion, or other state of being, perhaps one that cannot be spoken. What we see in these images we cannot always explain, but the more we open our mind's eye, the more we recognize. □

— VAL SCHAFFNER

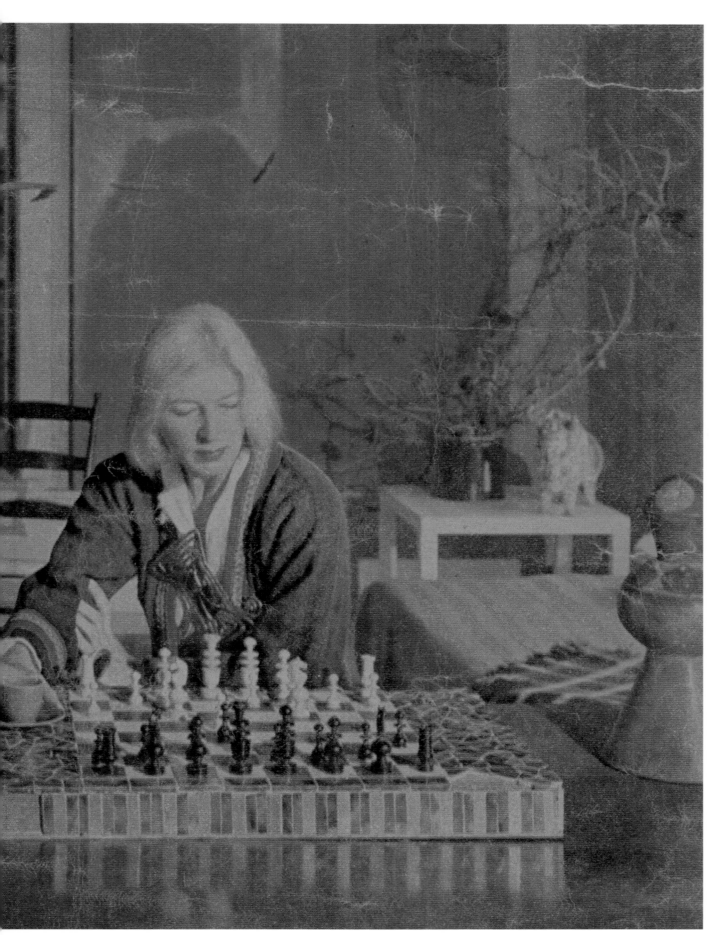

Ten Haeff at "Red Barn," Amagansett, New York, 1960
Photograph by Hans Namuth,
Center for Creative Photography, University of Arizona

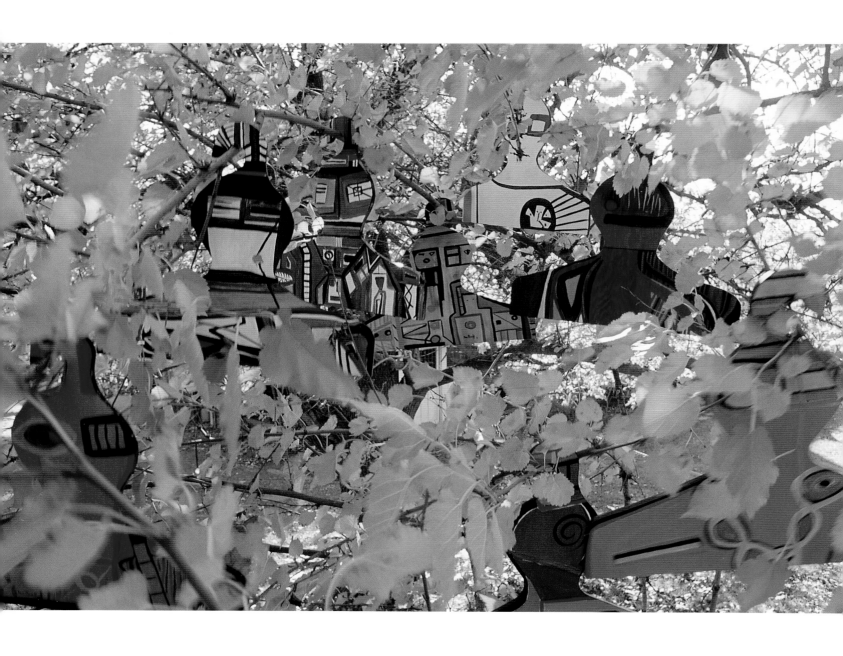

Hanger Series in a Mulberry Tree, Stony Hill Farm, Amagansett New York, 1966
Photograph by Adelaide de Menil

chronology

1915 born in Duesseldorf, Germany.

1933–40 studies voice and music with Maria Schultz-Dornburg and Walter Frank in Berlin.

1940 marriage to Dr. Lutero Vargas, son of Dr. Getulio Vargas, President of Brazil, moves to Rio de Janeiro, becomes Brazilian citizen.

1942 studies sculpture with Polish émigré sculptor Count August Zamoyski in Rio de Janeiro.

1944–5 receives Rockefeller fellowship for study at the Juilliard School in New York.

1947–8 divorces, returns to New York from Brazil, works as assistant to art connoisseur and dealer J.B. Neumann.

1948 marriage to architect and city planner Paul Lester Wiener, becomes U.S. citizen.

1948–56 extensive travel and long sojourns in Latin America as Wiener, in partnership with Josep Lluis Sert and Le Corbusier, prepares master plans for Lima, Bogota, and other cities; collects pre-Colombian and Spanish colonial art.

1953 begins regular summer residence in Amagansett.

1957 begins to draw and paint under the guidance of Elsa Tennhardt, an artist and art instructor at New York University, and a longtime resident of Southampton.

1967 death of second husband, Paul Lester Wiener.

1969 marries Slavist and translator John Lawrence Githens, assistant professor of Russian at Vassar College.

1976, 1980 extensive travel and residence in Central America

1977–1978 extensive travel and residence in Japan and Korea.

1982, 1984 sojourns in Burma and Indonesia.

1989, 1992 extended stays in Thailand.

SELECTED EXHIBITIONS

1963–4 participates in traveling group exhibition *Sudamericanische Kunst der Gegenwart:* 6/3–9/1/63 Haus der Stadtischen Kunstsammlungen, Bonn; 1/12–2/9/64 Akademie der Kunst, Berlin; March-April 1964 Staatliche Kunsthalle, Baden-Baden, Germany.

1966 one person show at The New School Associates Gallery, New York, NY. Group show at the Parrish Museum, Southampton, NY.

1969 one person show at the Benson Gallery, Bridgehampton,

NY. Major retrospective exhibition at the Hudson River Museum Yonkers, NY, *Two Visions of Space,* with 45 paintings by ten Haeff and 69 paintings by Bauhaus artist Herbert Bayer.

1971 group show *Long Island Painters,* at Guild Hall Museum in East Hampton, jury award by Mr. Edward Fry of the Metropolitan Museum of Art.

1972 group show *20th Annual Fine Arts Awards* at the Parrish Art Museum, Southampton, jury award by Ms. Lansner of MOMA, leading to a subsequent show of 11 works at the Parrish Art Museum in November.

1973 group show *Flowers,* curated by Christophe de Menil with the assistance of Donald Droll and Paul Magriel, at Guild Hall Museum, East Hampton, NY.

1974 group show *Then and Now* curated by Eloise Spaeth at Guild Hall Museum, East Hampton, contrasting early and recent works by Tony Rosenthal, Jimmy Ernst, Ibram Lassaw, Sid Solomon, Alfonso Ossorio and Ingeborg ten Haeff.

1976 one person show at Galerias Mer-Kup in Polanco, Mexico City.

1980 group show *A Point of View* at Guild Hall Museum, East Hampton, NY, curated by Harriet Vicente, and including five drawings from ten Haeff's *Chiromancy* series.

1980 One person show of 25 drawings from the Chiromancy series at the Elaine Benson Gallery, Bridgehampton, NY. Group show *Portraits, Real and Imagined* at Guild Hall Museum in East Hampton, curated by Eloise Spaeth and including portraits of author Dwight Macdonald and of artist Balcomb Greene from the *Chiromancy* series.

1983 jury award by Mr. Saul Wenegrat, curator of the art collections of the Port Authority of NY and NJ, for drawing exhibited at the *45th Annual Artist Members Exhibition* at Guild Hall Museum, East Hampton, NY.

1988 particpates in the *3rd Annual Invitational Exhibition* at the Benton Gallery, Southampton, NY.

1989 one person show at the Benton Gallery, Southampton, NY.

1992 group show *Free Spirits* at the Elaine Benson Gallery, Bridgehampton, NY.

1997 group show *Abstract in Particular* at the Nabi Gallery, Sag Harbor, NY.

1998 Group show *Inner Realms* at the Nabi Gallery, Sag Harbor, NY

2000 Group show *The White Album* at the Nabi Gallery, Sag Harbor, NY

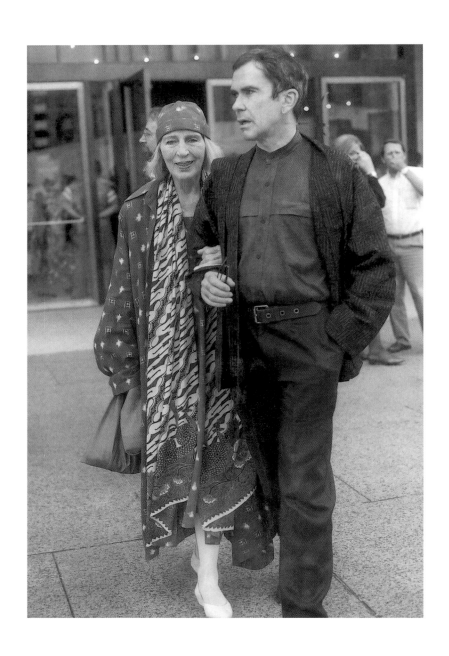

Photograph by Bill Cunningham, 1992